W9-APH-584

POST-IMPRESSIONISM

MOVEMENTS IN MODERN ART

POST-IMPRESSIONISM

BELINDA THOMSON

CAMBRIDGE
UNIVERSITY PRESS

PUBLISHED BY THE PRESS SYNDICATE OF THE
UNIVERSITY OF CAMBRIDGE
The Pitt Building, Trumpington Street, Cambridge CB2 1RP,
United Kingdom

CAMBRIDGE UNIVERSITY PRESS
The Edinburgh Building, Cambridge CB2 2RU, United Kingdom
http://www.cup.cam.ac.uk
40 West 20th Street, New York, NY 10011-4211, USA
http://www.cup.org
10 Stamford Road, Oakleigh, Melbourne, 3166, Australia

First published by Tate Gallery Publishing Ltd, London 1998

Cover designed by Slatter-Anderson, London
Book designed by Isambard Thomas
Typeset in Monotype Centaur and
Adobe Franklin Gothin

Printed in Hong Kong by South Sea International Press Ltd

Library of Congress Cataloguing-in-Publication Data is available.

A catalogue record for this book is available from the British Library

Measurements are given in centimetres, height before width,
followed by inches in brackets

Cover:
Vincent van Gogh, *Vincent's Chair with his Pipe* 1888–9
(detail of fig.22)

Frontispiece:
Roger Fry, *Studland Bay*, 1911 (detail of fig.50)

ISBN 0 521 64609

Contents

Introduction: The Term 'Post-Impressionism'

One of the perennial challenges faced by the exhibition organiser, and one that is all too often left until last, is the necessity to come up with a title for an exhibition. To please the public and arrest the attention of the press, this title must be catchy, yet it must also be truthful and descriptive. The term Post-Impressionism was coined at just one of these awkward moments. In late 1910 Roger Fry, known in Britain as an inspiring lecturer on art and in America as a curator specialising in the purchase of Renaissance art for New York's Metropolitan Museum, put together at short notice an impressive if somewhat heterogeneous selection of recent French art from the stock of a number of Parisian dealers. Initially he thought the term 'expressionist' might serve his purpose, and alert the uninitiated viewer to what was new and characteristic about the different works. However, he ultimately settled for the more non-committal, portmanteau term Post-Impressionist.

Fry's exhibition *Manet and the Post-Impressionists*, held at the Grafton Galleries from November 1910 to January 1911, was diverse and uneven in the extreme. Alongside works by Edouard Manet, it included large groups of paintings by Paul Cézanne, Vincent van Gogh and Paul Gauguin, and came right up to the present with a sprinkling of works by living artists, Henri Matisse, Pablo Picasso and their followers. Fry was later apologetic about the term, admitting that it was arrived at for want of anything better, as these things so often are. Later we shall examine in more detail the circumstances of the term's first usage and the consequences of the Grafton

Galleries exhibition for the unsuspecting Edwardian art world. For present purposes however it is important to consider the meaning and usefulness of the term.

One can see why it was desirable, from Fry's point of view and for the sake of historical comprehensibility, to draft in a catch-all label. The need had already been felt in France, where, in 1895, the alert young artist and theorist Maurice Denis pointed out that his own and his friends' work (by which he meant fellow Nabis, Emile Bernard and Louis Anquetin, Gauguin and the Pont-Aven group and others) had so far given rise to a confusing succession of conflicting style labels: 'cloisonnists, synthetists, neo-traditionists, ideaists, symbolists and deformers'. These had been put forward by critics of the late 1880s and early 1890s such as Edouard Dujardin, Gustave Geffroy, Albert Aurier and Maurice Denis himself. Since 1886 the term Neo-Impressionist had also been in use, attached by Félix Fénéon to the group led by Seurat. Post-Impressionism was the first term to encompass this whole generation of innovators, and as such it has always had in-built advantages and disadvantages.

It posits the belief that the revolution in style ushered in by the Impressionists in the 1870s was both so distinctive and so profound that all advanced art that came after it was irretrievably altered; in short, artists of the 'Post'-Impressionist generation (broadly speaking, advanced artists who began working and exhibiting in France around or after 1885–6), could not but respond to Impressionism and, in the absence of another clear-cut unifying characteristic, this irrefutable fact was enough somehow to define them. Non-committal and vague as this may seem, it emerged in Fry's subsequent writings that he intended to define something more distinctive, dynamic and revolutionary. The Post-Impressionists, for him, were a generation of artists who consciously emphasised and exploited the formal elements inherent in the medium – in the case of painting, the decorative elements of colour, line and composition – as the means whereby to convey or express emotion. At the same time, the Post-Impressionists avoided or played down the elements that they considered inessential to picture-making – three-dimensional illusionism (a laborious technique that was nothing but a distraction and could safely now be considered the domain of photography) and narrative content (which was the the domain of literature). Indeed Fry argued that the choice of subject matter in painting was largely irrelevant to its aesthetic value. In 1912, in the catalogue of his *Second Post-Impressionist Exhibition*, Fry was to state unambiguously where this new tendency came from: in France, at least, all Post-Impressionist developments derived in some measure 'from the great originator of the whole idea, Cézanne.'

One of the drawbacks of the term is that it imposes retrospectively a unity of aim upon the Impressionists and on those who reacted against them when in reality little or no unity existed. There was always, for instance, the awkward disparity between landscape and figure Impressionism, as typified respectively by Monet and Degas. Moreover the exclusive emphasis on the legacy of the Impressionists as against other

tendencies over-simplifies and distorts the story. Reading art criticism of the late 1880s and 1890s, one realises that it was in fact only a handful of critics who were able to discern a growing dissatisfaction with the Impressionist idea, and not a serious concerted reaction against it. Common aims can, however, be found when looking at separate, more closely-knit sub-groups, the Pont-Aven artists, the Nabis or the Neo-Impressionists. There was a degree of cross-over between the members of these sub-groups, and their immediate followers the Fauves borrowed and freely combined elements of stylistic innovation from them all. Perhaps partly due to the Fauves' random pillaging, it was possible after an interval of twenty-five years for an alert observer such as Roger Fry to discern more general factors linking this remarkable generation of innovators. Paradoxically, once Fry's ideas became institutionalised in museum displays around the world, viewers became so accustomed to detecting kinship at the stylistic level between van Gogh, Gauguin and Cézanne, in their choice of palette, their emphasis on bold, unvariegated colour and simplified and stylised linear forms, that art historians had to struggle to present their works in other ways.

Another problem with the term, given the evident historical motivation for its coining, is that no clear chronological starting point can be given to Post-Impressionism. In this respect it is distinct from Impressionism, whose public existence dates from the first group exhibition in 1874. Fry himself left the question unresolved by including in his Grafton Galleries exhibition paintings by Cézanne such as the *House of the Hanged Man* (fig.1) which had been shown at the first Impressionist exhibition in 1874! The well-informed francophile Walter Sickert was quick to point out this slip in his review, describing Fry's show to the readers of the *Fortnightly Review* in January 1911 as 'an earth-shaking jumble … where everything was booked through, like the baggage of a travelling company, as "Post-Impressionism", including Cézanne who was, if anything, rather Pre-Impressionist'. Nor should one forget that several of the leading Impressionists, Auguste Renoir, Edgar Degas and Claude Monet, had not reached the end of their careers by 1910.

A further problem arises if one accepts that what Fry was describing was a loss of faith in the Impressionist aesthetic, that Post-Impressionism could be defined as 'anti-Impressionism' to borrow the words of Clive Bell. Such a loss of faith certainly did come about in certain cases, gradually in Gauguin's for instance, suddenly and violently in the case of twentieth-century artists such as Maurice de Vlaminck, André Derain or Duncan Grant. But the same cannot be said of Cézanne, the supposed originator of the movement. However persuasively critics might insist upon those formal aspects of Cézanne's work that separate him from the Impressionists (the concern for solid form, for tactile values, for representing not sunlight itself but its effects, through a painterly equivalence, colour), the fact remains that the only common aim to which Cézanne subscribed was that of Impressionism. To the end of his career he clung obstinately to the notion of the Impressionist 'sensation' and to the practice of working in front of nature.

1
Paul Cézanne

House of the Hanged Man 1873

Oil on canvas
55 × 66 (21¾ × 26)
Musée d'Orsay, Paris

The reason that, despite all these shortcomings, the term Post-Impressionist remains in currency today must be that it answered and continues to answer a need. Thanks to the rumpus caused by Fry's 1910 exhibition, the term was used repeatedly in the British press between 1910 and 1913 when the last of three exhibitions which used the term in its title, *Post-Impressionists and Futurists*, was held. This repeated use of the new buzz word was sufficient to imprint it on the critics' and public consciousness, so that it survived the hiatus of the First World War when much cultural

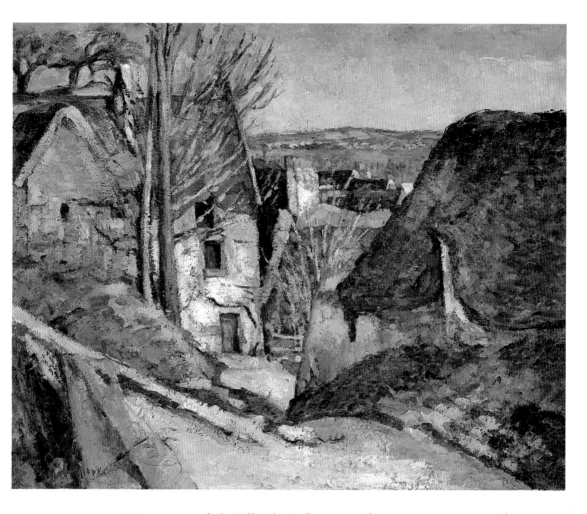

activity came to a halt. Tellingly, in the 1920s, when new companion guides to the modern collections of the National Gallery and the Tate Gallery were published, written by their respective directors Sir Charles Holmes and J. B. Manson (each practising painters on the fringes of the modern movement), we find the term Post-Impressionist being introduced, albeit sparingly and cautiously. When the new Museum of Modern Art in New York opened in 1929, its inaugural exhibition was devoted to the four great masters of Post-Impressionism (*Cézanne, Gauguin, Seurat, van Gogh*) whose works now fetched dizzying prices on the international art market. The curators had accepted

the idea that this rupture in the history of nineteenth-century art marked the true beginning of modern art, whose paternity had been widely attributed to Cézanne.

Over time it has become expedient to recast and broaden the term Post-Impressionist to include artists who were not in the least disenchanted with Impressionism, but who wished to take it further than the instigators of the group had planned or envisaged. Only such a definition encompasses the pioneering developments introduced by Seurat and the Divisionists in the later 1880s and 1890s, whose work Fry later regretted he had largely ignored in 1910, and Bonnard's and Vuillard's evolution after 1900, when they consciously set about picking over and trying on a number of Impressionism's cast-offs.

In France, understandably, there was greater resistance to the term Post-Impressionism. Maurice Denis, one of the most influential theorists to analyse the broad stylistic changes Fry's term described, only began to use the term towards the end of his life. Pierre Francastel, when writing his study *Impressionisme* in 1934, implicitly rejected it by making a strong case for conceiving of Impressionism under a much broader rubric, as part of a continuum, a new vision or world view, not a technical formula or a style through which one could pass. On the other hand the crucial importance of the phenomenon it describes was acknowledged when René Huyghe wrote in 1949: 'If modern art exists, much more than to the Impressionists it owes its existence to that team of great creators who succeeded them around 1885, who reacted against them, who conceived a pictorial vision that was new and unexampled for centuries.' Today, thanks to the influence of John Rewald's seminal scholarly study of 1956, the label Post-Impressionist has been widely accepted and is frequently encountered in France's major museums, performing its most useful, but essentially limited function: that of a signpost.

So there are really two Post-Impressionist stories to be told. The first and most complex is how artists in the 1880s and 1890s worked over the possibilities opened up by Impressionism and broke free of its limitations and orthodoxies. This was a Europe-wide phenomenon but space only permits consideration of the key developments in the orbit of Paris, in particular of the group initiatives, and of the individuals who succeeded in funnelling group aspirations. The second concerns the critical assimilation of those developments and the more localised story, to be dealt with summarily in the final chapter, of how Fry's identifying and implanting the concept of 'Post-Impressionism' gave new impetus to art practice and collecting in Britain and further afield, a story told singularly well by the collections of the Tate Gallery.

THE 1880s

SEEDS OF DISSENT

When can we first trace dissatisfactions with Impressionism and attempts to take the idea one stage further? Conventionally historians cite the Impressionists' eighth exhibition, held from 15 May to 15 June 1886, as a significant moment of change. It proved to be the last group show although that eventuality could scarcely have been imagined by the participants. But well before that date, and in diverse places, one can detect signs of dissent from the core Impressionist idea.

There were, for instance, the continuing caveats of the critics of Impressionism, convinced from the outset that however fresh and welcome this art of rapid, momentary sensation might be, offering a change from the outworn routines and sombre tonalities of academic painting, it was incomplete in itself, only a prelude to a more substantial form of art yet to come. There was Cézanne's abstention after 1877 from further Impressionist exhibitions, stung by the critics' incomprehension of his efforts. He was aware too of his lack of fit with this art of spontaneity but incompletion, an unease signalled by his ponderous use in titles of such qualifications as *Study from Nature* or *Head of a Man; Study* (see fig.2). At the same time he was convinced of the value of his ultimate goal and determined to pursue it without compromise. There were the doubts expressed severally by others of the group, particularly those who admired Cézanne – Pissarro first, then Renoir, then Gauguin – about Impressionism's lack of a solid methodology.

All three sought to strengthen their technique by concentrating on drawing, turning to the least Impressionist of the Impressionists, Edgar Degas, for advice and example, as well as to the earlier traditions of draughtsmanship to which he was heir (see Pissarro's *The Pork Butcher*, fig.3). Finally, in 1886, there was Seurat's demonstration of what could be achieved if rigorous principles were applied to the Impressionist palette and brushstroke as a corrective to its hitherto intuitive, arbitrary and unscientific practice.

From the inaugural exhibition in 1874 the Impressionist group had never comprised a fixed membership. New recruits appeared at each of the subsequent group exhibitions, some of whom as quickly disappeared again, whilst others remained. Each such accommodation caused the Impressionist idea to shift imperceptibly. There were the clumsy and awkward technicians like Armand Guillaumin, Cézanne himself, and Paul Gauguin, introduced by Pissarro in the late 1870s, who were eager to learn from their colleagues' example, and emulated their ability to analyse and capture, through broken touches of colour, the way shifting light transformed landscape. Through their laborious efforts they gained the acceptance of their peers. Several other newcomers – Gustave Caillebotte, Federico Zandomeneghi, Mary Cassatt, Jean-Louis Forain, Jean-François Raffaëlli – owed their introductions to Degas, whose interests were not so much in *plein-air* (open air) painting as in the chance visual effects thrown up by modern urban life. Degas interpreted his subjects through arresting methods of drawing and composition developed in a complex studio practice. By 1881 the presence of these outsiders was felt to have created an imbalance in the group, particularly as Monet, Sisley and Renoir had chosen that year to abstain in order to exhibit once again at the official Salon.

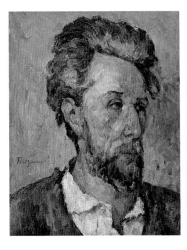

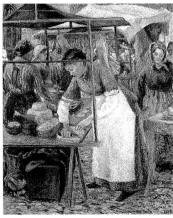

The decision to exclude Raffaëlli the following year, which in turn influenced the return of the three major landscapists, resulted in a seventh exhibition in 1882 that was far closer to the profile of the original. This was important as it allowed critics the chance to re-examine the core concept of Impressionism (already the term was being used loosely of any bright-toned painting of modern subject) and see how it had developed over the eight years of its existence. For Jacques de Biez, writing for the journal *Paris*, the continuing aptness of the Impressionist label was all too apparent, since the faults that critics had homed in on in 1874 remained uncorrected: 'Impressionists they wished to appear, impressionists they have remained. Of course we are all impressionists in a large acceptance of the word. The impression has a place in all the arts, since it is the first stirring … One does not become an artist except on condition that one goes back over that initial impression, in order to give it an appropriate development. It's for refusing

to have that patience and for stopping obstinately at the point where that reflective development should begin that the independent artists are "impressionists".'

THE TURNING OF THE TIDE

Exceptionally, the next group Impressionist show did not take place for another four years by which time the cultural climate had significantly changed. Two unrelated events in 1884 can be seen as symptomatic. One was the founding of the *Revue Indépendante*, which offered an outlet to young writers and critics associated with the latest developments in literature as it

2
Paul Cézanne

Portrait of Victor Chocquet (Exh. 1877 as *Head of a Man; Study*) 1876–7

Oil on canvas
45.7 × 36.8
(18 × 14½)
Private Collection

3
Camille Pissarro

The Pork Butcher 1883

Oil on canvas
65.1 × 54.3
(25¾ × 21½)
Tate Gallery

4
Georges Seurat

The Bathers, Asnières 1883–4, retouched *c.*1887

Oil on canvas
201 × 301.5
(79¼ × 118¾)
National Gallery, London

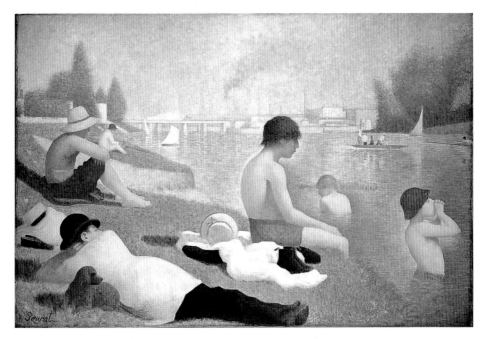

evolved from naturalism towards symbolism. The second was the simultaneous establishment of the new Salon des Indépendants, whose jury-free exhibiting forum offered a brighter future for experimental artists. Its founders had undoubtedly been inspired by the Impressionists' example, but their society's membership was far less exclusive, welcoming a broad range of styles, from the darkly mysterious, fantasy images of Odilon Redon (himself a founder member) to the naturalist landscapes of artists such as Dubois-Pillet. Georges Seurat had caused a considerable stir at the first *Indépendants* exhibition in 1884 with *The Bathers, Asnières* (fig.4), having just suffered the indignity of its rejection by the official Salon.

When Seurat was invited to exhibit at the Impressionists' eighth exhibition in 1886, Pissarro had argued for his inclusion more out of homage to what he had already achieved than as a device for drawing

promising young talent into the fold. But in a sense Pissarro was taking a calculated risk and not all the old Impressionists supported the invitation. Gauguin was one who welcomed the new blood; as a relative newcomer himself he had been anxious to avert the danger of the group's disintegration at the start of the decade, feeling its future was being jeopardised by a new strategy of the Impressionists' dealer, Durand-Ruel, to promote individual talent in a series of one-man shows at the expense of group unity. Thus Gauguin was optimistic about the 1886 exhibition: 'we are going to hold a very comprehensive exhibition', he explained to his wife, 'with some talented new Impressionists. For some years now all the schools and studios have been preoccupied by it, and it is reckoned this exhibition will create quite a stir, perhaps it will prove the turning of the tide.'

Seurat was the first new recruit to Impressionism to arrive fully armed with a highly developed style, with nothing left to learn and with no intention of allowing himself to be deflected from his chosen path. The concentrated group of pastels by Degas for instance, which showed women in the tub and performing their toilette (fig.5), one of the aspects of the exhibition which impressed the critics and was grudgingly admired by Gauguin, left no mark on Seurat at all. He had already knowingly adopted those aspects of Impressionism he found useful (the broken brushwork and prismatic palette) and grafted them on to a style derived from a thoroughly academic training. For Seurat had undergone the kind of Ecole des Beaux-Arts training, along the guidelines laid down by academician Charles Blanc, that had been purposely avoided by the less rigorously taught Impressionists, and the group of paintings he showed, which included *Le Bec du Hoc, Grandcamp* and *Sunday Afternoon on the Island of La Grande Jatte, 1884* (figs.6, 7), could certainly not be faulted on grounds of slapdash technique or incompletion. These works were methodical, luminous, skilfully crafted. Here was a highly accomplished young master who already had a following in fellow *Indépendant* Paul Signac and in the Pissarros, father and son.

Whereas Raffaëlli had been an unacceptable addition (he was judged to be a self-serving opportunist exploiting the Impressionists' contacts and publicity machinery), Seurat's intervention proved in a sense more silently

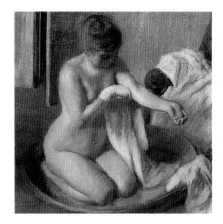

5
Edgar Degas

Woman in a Tub
c.1883

Pastel on paper
70 × 70 (27½ × 27½)
Tate Gallery

6
Georges Seurat

*Le Bec du Hoc,
Grandcamp* 1885

Oil on canvas
64.8 × 81.6
(25½ × 32)
Tate Gallery

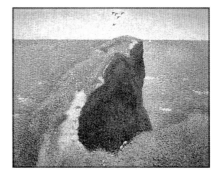

7
Georges Seurat

*Sunday Afternoon on
the Island of La Grande
Jatte, 1884* 1884–5

Oil on canvas
205.7 × 305.7
(81 × 120½)
Art Institute of Chicago,
Helen Birch Bartlett
Collection

disruptive, effectively causing the capitulation of any further effort at Impressionist group unity and bringing about the coining of a new style label, Neo-Impressionism. Within a year Seurat had sufficient followers to form a separate splinter group, as the Divisionist method he had patented (nicknamed 'pointillism' by the critics) became a manner that spread through the studios like a rash. Seurat's style, informed by Impressionist subject matter and colour, but a severe corrective to it, marked a decisive new step towards the creation of an art of permanence from the raw material of Impressionism.

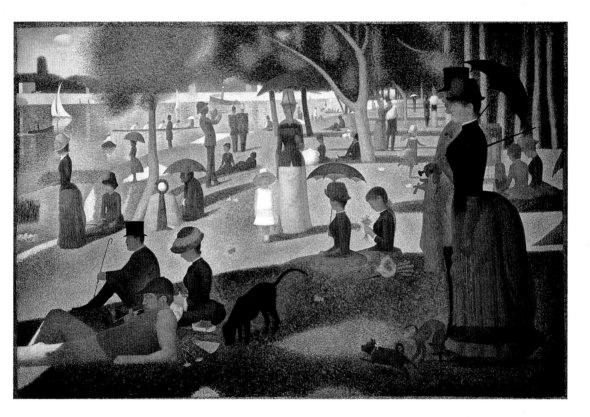

THE IMAGE OF THE ARTIST: SEURAT THE SYSTEMS MAN

The strange dignity and formality that, in 1886, struck many critics looking at Seurat's enormous painting of Sunday strollers on the island of La Grande Jatte seem to have been equally characteristic of the man. Art was a serious business for Seurat, the son of a nouveau riche legal official, and to achieve results commensurate with its morally uplifting purpose required a faultless technical mastery. The cool methodicalness of his approach was to occasion some unflattering nicknames from fellow artists: Degas and Gauguin respectively dubbed him the 'notary' and the 'chemist'. Seurat saw no place for overly personal expression through choice of subject or

intuitive quirks of individual handling. Only rarely did he attempt anything new in terms of subject; his strategy was to enlarge to a monumental scale and make a synthesis of the kind of modern subjects explored earlier by Monet, Renoir and Caillebotte, subjects Henry James had described in 1876 as 'crudely chosen' and 'loosely treated'. Following the Impressionists' lead, many artists in the 1880s took their easels down to the suburban quays and tackled motifs from the riverside, particularly favouring the burgeoning western suburbs of Asnières or Clichy: one thinks of Guillaumin, Gauguin, van Gogh, Bernard, and Signac whose *Gasometers at Clichy* (fig.8) was one of the three fully Divisionist canvases he exhibited in 1886. It was a demonstration of commitment to uncompromising truth and modernity. The suburbs had also proved fruitful terrain for naturalist writers and

8
Paul Signac

Gasometers at Clichy
1886

Oil on canvas
65 × 81 (25½ × 32)
National Gallery of
Victoria, Melbourne
Felton Bequest 1948

9
Georges Seurat

*The Lighthouse at
Honfleur* 1886

Oil on canvas
66.7 × 81.9
(26¼ × 32¼)
National Gallery of Art,
Washington

poets, intrigued both by their odd, uneasy blend of new building with natural beauty and their mixed, shifting population of workers and leisure-seekers.

When he embarked on the first of his major figure subjects in 1883–4, Seurat had already, by dint of repeated studies of the human figure, developed an unusually schematic, anonymous form of characterisation, devoid of all extraneous detail. His sophisticated drawings in soft conte crayon on grainy paper exploited the medium for the velvety textures and negative/positive effects it could yield. His painting manner had evolved from the chopped straw handling of *The Bathers, Asnières* to the dotting technique used first in the summer of 1885 in *Le Bec du Hoc* and subsequently, albeit only in the final paint layer, in *La Grande Jatte*. The resulting synthesis

was similar to the drawings — a distancing of the subject achieved by the contrasting means of covering the canvas surface with an even spread of regular dashes or dots. The colours had to be applied in carefully measured-out doses of complementary hues so as to achieve maximum light-scattering luminosity. The theory behind this colour division owed something to Delacroix's methods, which Seurat understood to have been informed by the chemist Eugène Chevreul's prescriptions for simultaneous contrasts of colour as applied in the manufacture of tapestry, and something to the optical experiments of the American chemist Ogden Rood. The Divisionist procedure demanded almost mechanical patience and self-denial; there was clearly no possibility of achieving satisfactory, balanced results except in the studio.

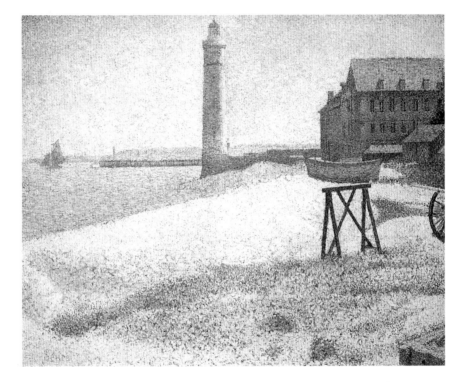

For a few years in the late 1880s Pissarro was drawn to emulate Seurat's example, partly because Divisionism seemed the logical outcome of his own struggle to reach unity and the solution to his increasingly congested brushwork, and partly as a reaction to an excessively personal, romantic tendency he saw creeping into Monet and Renoir's recent works done in the open air, such as the group of seascapes Monet painted at Etretat. Seurat too must have had Monet in mind when he set himself the task of painting seascapes from the Normandy cliffs — *Le Bec du Hoc* being the first of a long series — and it is difficult not to see an element of competitiveness in the attempt. Summer after summer he was to return to the Channel coast (though rarely to the same spot twice), methodically pursuing his mysterious goal. What that goal was we have only the resulting pictures to

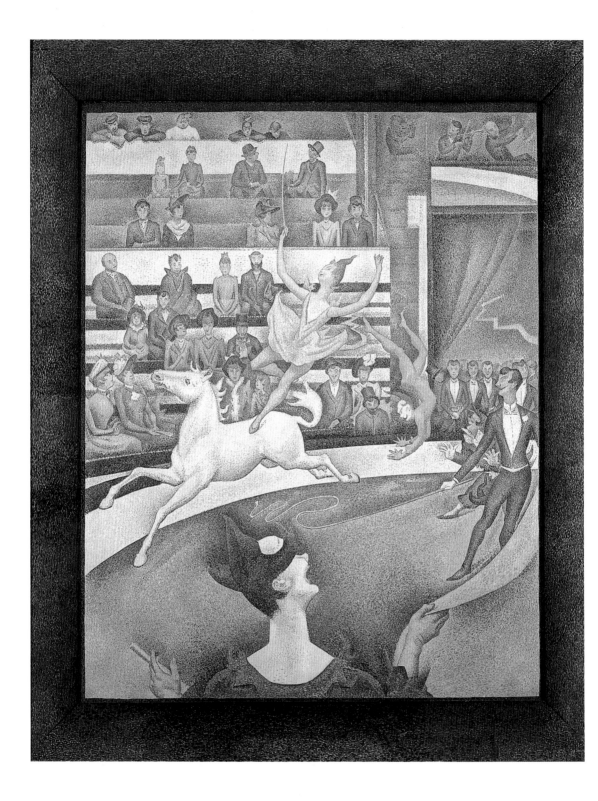

convey, for Seurat was extremely reticent about his aims. Clearly the power and romantic changeability of the sea did not hold the same fascination for Seurat that it did for Monet: his seascapes are invariably serene and still. Indeed the very oddness of the motifs he selected suggests that what held his attention was creating a pictorial harmony from this stillness and from the contrasts between nature and artifice, a theme equally identifiable in Seurat's large-scale figure pictures. In *The Lighthouse at Honfleur* (fig.9), unpicturesque new buildings create stark juxtapositions with the harmonious natural pattern of the sea and shore. In *Circus* (fig.10), the last of his sequence of carefully contrived modern city paintings, artifice literally has the whip hand! Dynamic movement is indicated by diagonals and swirling arabesques, while Seurat's schematically indicated circus audience arrayed in their hierarchical tiers is reduced to a caricatural jocular dumbshow. Perhaps he sought, in the repetitive angles and curves of his drawing and his disciplined high-key palette of blue, yellow and orange, a painterly equivalence for the disciplined repetitions of movement and contrived gaiety that lie behind the acrobats' displays.

THE SEARCH FOR A SOLID METHOD: CÉZANNE

10
Georges Seurat

Circus 1890–1

Oil on canvas
186 × 151.1
(73¼ × 59½)
Musée d'Orsay, Paris

Nothing could have been further from the image of Seurat as an artist than the colourful chaos of bohemian studio life evoked by the novelist Emile Zola in *The Masterpiece* (*L'Oeuvre*), published in 1886. Admittedly Zola's central character, Claude Lantier, is represented as a failed artist who ultimately commits suicide, rather than as a precociously successful one. However, Lantier's uncomfortable resemblance to the touchy, saturnine Cézanne, Zola's childhood friend from Aix-en-Provence, exacerbated the rupture in the friendship between these two extraordinary individuals, each destined to achieve great things in his chosen field. In earlier, happier times, on one of his regular visits to Zola, Cézanne painted *The Château of Médan c.*1880 (fig.11), a view of the spot beside the Seine where Zola had recently bought a country retreat with the proceeds of his writing. Thus the painting can at one level be seen as an acknowledgment of his friend's success – *Les Soirées de Médan* was the name given to the collective publication of Zola's naturalist circle, which included some of Impressionism's most supportive critics such as Joris-Karl Huysmans and Paul Alexis. But the tribute is of a suitably distanced and objective kind in that Cézanne chose to view his motif from an island in the river. As a landscape it is also an excellent example of the revolutionary new manner of painting developed by Cézanne around 1879–80. His motif of buildings among trees, typically devoid of human presence, is tightly organised into a horizontal plane with the symmetrically placed verticals of tree trunks providing balance. The dense unity of the composition, and its shallow space, are increased by the regular, diagonally hatched brushstrokes which give a solidity to the land in contrast to the horizontals of the water and the more loosely treated band of sky.

It is a sad indication of the growing gulf in understanding between painter and writer that this highly accomplished painting was never owned by Zola. Indeed Zola was one of those critics who argued that the Impressionists had failed to progress beyond their hesitant beginnings. Instead the painting was acquired around 1882 by Paul Gauguin from the colour merchant Père Tanguy. Gauguin had recently been introduced to Cézanne's work by their mutual Impressionist mentor Camille Pissarro, and he was quick to sense that Cézanne's period of solitary effort in the south of France had resulted in a decisively new kind of Impressionism. Gauguin urged Pissarro to note down anything of significance Cézanne might let slip about his working method: 'If he should find the recipe for giving full expression to all his feelings in one single procedure, I beg you to try to make him talk during his sleep by giving him one of those mysterious homeopathic drugs and come to Paris immediately and tell us all about it.' A more practical step Gauguin took was to acquire the *Château of Médan*, as well as five other Cézannes, for very little outlay, confident that they would prove a sound investment one day; and he adjusted his own style and brushwork in response to their example. In so doing Gauguin showed remarkable flair both as collector and artist, securing for himself one of the very first places in the line of Cézanne's admirers that was to grow from a handful of artists and enlightened collectors in the 1880s to its present-day proportions. But something about the opportunism of Gauguin's approach aroused Cézanne's suspicions, indeed his most paranoid tendencies, an occupational hazard of avant-garde innovation. He accused Gauguin of having robbed him of his precious 'little sensation'. The impossibility of fruitful exchange of ideas, the absence of camaraderie between the two artists, is a telling measure of the increasing tension and rivalry in the art world of the time.

Similar mistrust and jealousy prevented a friendship developing between Gauguin and Seurat in 1886, despite underlying parallels in their artistic objectives. Both were preoccupied by the idea that, just as was the case in music, a codifiable system underlay the way in which the realm of the visual conveyed meaning, so that over and above the literal meaning of a painting's subject matter, given lines and colours could be used to signify given emotions and moods. These ideas were to be found in simple form in Blanc's *Grammaire des Arts du Dessin*, and were being further explored at the time by mathematician and aesthetician Charles Henry whose *Introduction à une esthétique scientifique* appeared in 1885, and whose further writings were published in *La Revue Indépendante* in 1888. Both artists sensed that simplification and synthesis were the key. Gauguin's writings in 1885 show him thinking along the same lines as Henry about the aesthetic properties of colour and line, influenced in part by his admiration for Delacroix and the romantic painter's heightened expression of emotion, in part by the ideas about stasis prescribed in the text of a Turkish poet. However, the advancement of Gauguin's theories was not yet translated on to canvas, for his painting style, having assimilated the density of colour he admired in Cézanne, was stuck in a Pissarro-like rut.

11
Paul Cézanne

Château of Médan (Zola's House) c.1880

Oil on canvas
59 × 72 (23¼ × 28¼)
Glasgow Museums:
The Burrell Collection

By the summer of 1886 all the necessary conditions for Gauguin to join other converts to Seurat's Divisionism were in place. But, crucially this did not happen, for reasons which can only be ascribed to piqued pride and clashing personalities. Gauguin had staked much on his showing of paintings at the eighth Impressionist exhibition, only to see his achievements ousted from the critical limelight by the more accomplished technique of Degas and the newly dubbed Neo-Impressionists. Seurat too was on his guard against the political machinations of Gauguin, judging him to be expert at winding people up. The crucial spark was provided by a

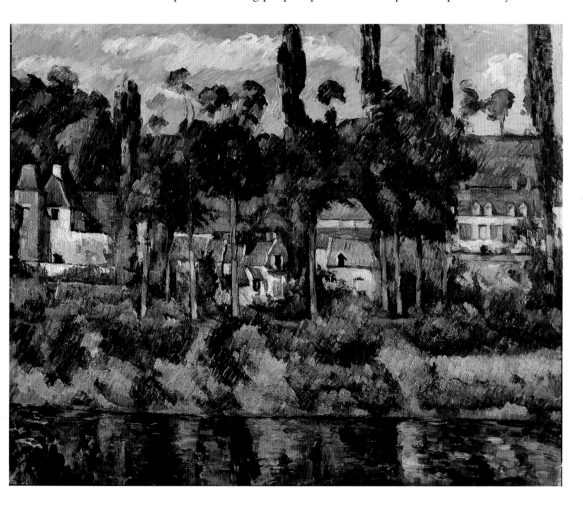

misunderstanding arising when Gauguin turned up at Signac's studio in his absence, having been promised its use over the summer, only to be turned away somewhat officiously by Seurat. 'I may be an artist full of uncertainty and lacking in erudition,' Gauguin protested to Signac, 'but as a man of the world *I will not accept that anyone* has the right to manhandle me.' The tone of his letter betrays much about the touchiness and frustrated ambitions of this renegade family man, this investments man turned painter. From this date on hostility and disdain characterised Gauguin's attitude to Neo-

Impressionism, and his choice of a separate artistic route was determined. It was a route which took him immediately to Brittany, and ultimately to the South Seas.

PARISIAN STRUGGLES: 'LE PETIT BOULEVARD'

When Gauguin mentioned to his wife the excited anticipation engendered among artists by the eighth Impressionist exhibition, the artists he had in mind were not necessarily names we remember today. His comment was applicable to certain of his own circle, which included Guillaumin and another latecomer to painting like himself, Ernest Schuffenecker; much was also expected of Impressionism by the up-and-coming generation of painters soon to emerge from the academic studios. A mood of expectancy certainly characterised a new arrival in Paris from Holland, Vincent van Gogh.

Fernand Cormon was one of a number of *pompier* (conservative, academic) painters to welcome students, and despite the thoroughly anti-modern cast of his own work – he specialised in mythical and prehistorical themes – he had a relatively tolerant attitude to the aspirations of the young. Among his students in early 1886 were a particularly talented but oddly assorted group, Emile Bernard, Louis Anquetin and Henri de Toulouse-Lautrec. The aristocrat Toulouse-Lautrec had left behind a rarefied country existence in the Languedoc to immerse himself in the camaraderie of the art world and the low life of Paris. His friend Anquetin, the son of a wealthy butcher from Normandy, had moved with Lautrec to Cormon's studio from that of Léon Bonnat, a portraitist of stricter teaching methods. In parallel the two artists had developed a commitment to modern subject matter and as they neared the end of their training were as likely to be found in the cabarets of Montmartre as in the Louvre. Emile Bernard, at the time of sitting for Lautrec's sensitive portrait (fig.12), was a high-minded, precocious but green seventeen-year-old. In taking up an artistic vocation he had had to overcome parental opposition, particularly when, at just about the time Vincent van Gogh was enrolling in Cormon's studio in the spring of 1886, Bernard was expelled for insubordinate behaviour. Thereafter he continued to pursue his idiosyncratic artistic education independently, inspired on the one hand by ancient religious art, on the other by the works of contemporaries, including Seurat and Cézanne.

Van Gogh's move to Paris had been undertaken with a clear objective: to make contacts and bring himself up to date with the latest developments in art. He could sympathise with the family opposition Bernard had experienced, having himself been banished from the presence of his Protestant father, a Calvinist minister (whose recent death had in a very real sense liberated him), and carrying in his psychological baggage a checkered

12
Henri de Toulouse-Lautrec

Emile Bernard 1885

Oil on canvas
54 × 44.5 (21¼ × 17½)
Tate Gallery

career of failed attempts at art dealing, teaching and pastoral work. Over the next two years the zeal van Gogh brought to his new artistic mission acted as a catalyst on the loosely connected group whom he dubbed the Impressionists of the 'petit boulevard', encouraging their experimental initiatives.

Already having clearly formed views on art and a style that, although clumsy, owed much to his Dutch forebears, van Gogh's initial reaction to the Impressionists was disappointment: he had been led to expect more, from the way they had been vaunted by his younger brother Theo, an art dealer employed by the Paris firm of Goupil and Co. But he was soon caught up, as were his new friends, in the imperative to experiment with the colour division technique pioneered by Seurat. Working alongside him on the quays, he encountered and drew close to Signac who was just beginning to

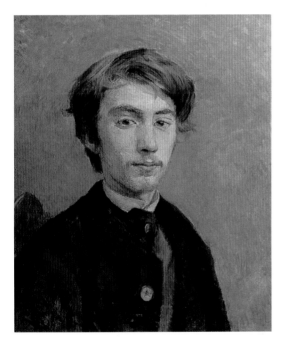

assume the rôle of propagandist for the theoretical principles underlying Seurat's Divisionism and was keen to welcome new adherents. So van Gogh's most characteristic Paris paintings show him trying out the various techniques and effects he saw in the neo-Impressionists' work, with unmixed colours applied as dots or dashes, and haloes around sources of light. On two occasions in 1887 van Gogh took the initiative of organising an *ad hoc* exhibition, both of which helped to focus his own and his contemporaries' thinking, opening up new directions and publicising their stylistic innovations. On the first occasion he decorated the walls of a neighbourhood café, Le Tambourin, with his own collection of Japanese woodcut prints; van Gogh had been an enthusiastic collector for some time and on reaching Paris he quickly located the shop of Samuel Bing where Japanese crêped prints could be bought very cheaply. The second exhibition, held at a newly opened spacious restaurant in Montmartre which he frequented, grouped together his latest paintings with those of a number of his new French friends.

During the later nineteenth century successive waves of Japanese influence had an impact upon the pictorial and decorative arts in France, and indeed in Europe generally. By the 1880s, scholarly books and journals were appearing on the subject and things Japanese had also reached the level of street fashion. So it was not so much the novelty as the timing of van Gogh's informal Japanese print show that was crucial for Bernard, Anquetin and Toulouse-Lautrec. A more comprehensive exhibition of Japanese masters, held at the Ecole des Beaux-Arts in 1890, would be of similar benefit to members of the Nabis group among others. For the new

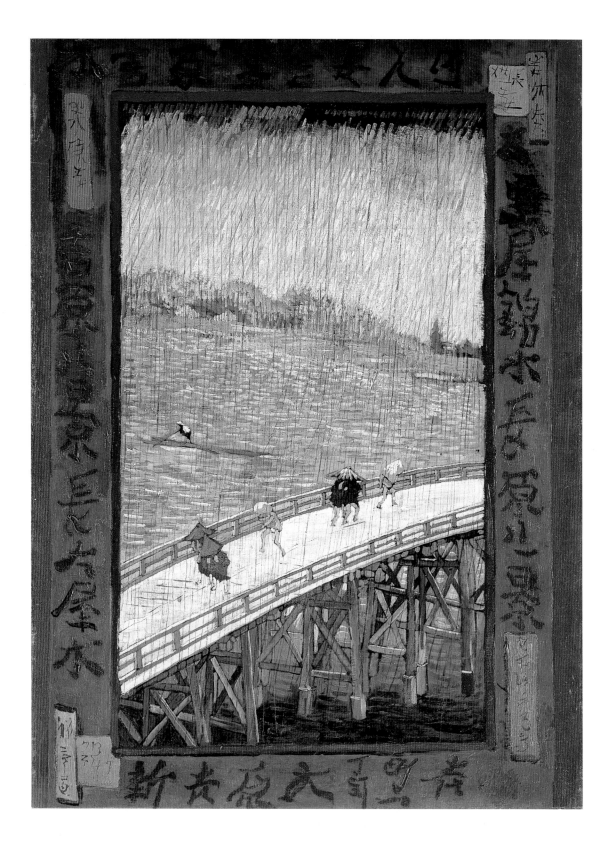

generation, two lessons could be drawn from looking hard at Japanese art (see Vincent van Gogh's *The Bridge in the Rain (after Hiroshige)*, fig.13). First, it created its own self-sufficient, stylised world parallel to nature, yet, like Impressionism, firmly based in reality and modernity, tackling topical city subjects such as street entertainment and prostitution. Then, on a technical level, the clear-cut, clean outlines and flat, unmodulated colours of the prints, still fresh to European eyes, demonstrated a form of simplification and synthesis that was immediate and decorative, diametrically opposed to the much softer-edged, imprecise results that could be achieved by the Divisionist procedure. Crucially, the example of Japanese art made it clear that many of the studio tricks developed since the Renaissance to perfect the artist's ability to imitate three-dimensional space and deceive the eye of the spectator (*trompe l'oeil* tricks that were still being monotonously drummed in to students in the teaching academies of Cormon and Julian) could be safely dispensed with in the interests of pictorial harmony. Moreover, for artists committed to modernity, Japanese conventions, which skilfully deployed only contour and plane, could be adapted for the purposes of popular illustration and caricature or for incisive drawn and painted images of Parisian life (fig.14). Toulouse-Lautrec's mature style for instance, first seen in his circus paintings of 1888 but developed in the famous posters of the 1890s, owed its bold arabesque stylisation and radical spatial design to the precedents of Japanese art combined with the more rococo decorative qualities of poster artist Jules Chéret. Indeed, Seurat himself was quick to respond to the new emphasis on linearity in his final unfinished figure painting, *Circus* (fig.10).

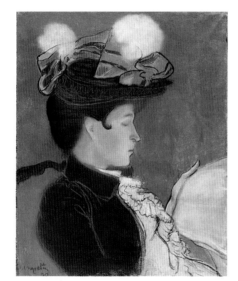

The second exhibition van Gogh organised, towards the end of 1887, at the popular Montmartre eating house Restaurant du Châlet, le Grand Bouillon, brought together, for the first time, examples of the boldly coloured linear style that Anquetin and Bernard, in direct response to seeing the Japanese works, had been exploring in their most recent paintings (see Bernard's *View from the Bridge at Asnières*, fig.15). These were quite distinct from works on show by Lautrec, van Gogh himself and a fellow Dutchman, Arnold Koning. Some weeks later, in an enthusiastic review for *La Revue Indépendante*, the Symbolist writer Edouard Dujardin came up with an appropriate name for this 'new and special manner' – 'cloisonnism' (by analogy with the *cloisonné* enamelling technique) – and made the key point

that it derived from a 'symbolic conception of art'. This crucially marks the essential difference between the Impressionist and the cloisonnist/synthetist artists' approach; where the former were still essentially concerned with representing reality in its most transitory form, the latter saw art as a vehicle for the expression of their subjective ideas about reality, or indeed, as was soon to be true of Gauguin's art, of the workings of their imagination.

Dujardin's account was undoubtedly tutored by Anquetin, a former school friend, and the main force behind the new style. Among Anquetin's pictures were three landscape views, each cast according to its subject in a yellow, blue or reddish-purple tonality. The last of these has sadly been lost,

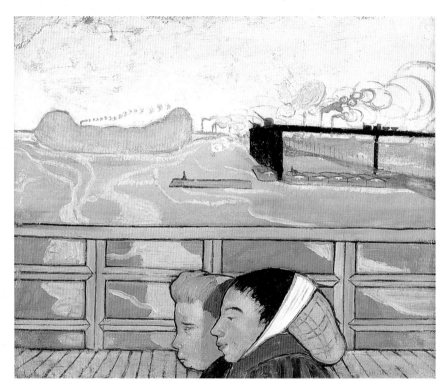

15
Emile Bernard

View from the Bridge at Asnières 1887

Oil on canvas
38 × 46 (15 × 18¼)
Musée des Beaux-Arts, Brest

16
Louis Anquetin

Evening: Avenue de Clichy 1887

Oil on canvas
69.8 × 53.3
(27½ × 21)
Wadsworth Atheneum, Hartford. The Ella Sumner and Mary Caitlin Sumner Collection Fund

but Anquetin's cloisonnist views of a man scything in a golden yellow field (*The Reaper*) and of a busy street scene in Montmartre (*Evening: Avenue de Clichy*, fig.16) – its blue cast indicating the time of day – were to prove of seminal importance. In the immediate aftermath of the exhibition, which was closed prematurely due to objections raised by the restaurant's clientèle, van Gogh, its chief organiser, felt bitter and depressed. Indeed, this was the mood in which he left Paris for Arles in February 1888. Never the less, thanks to his proactive energies, important ideas had been communicated and contacts made. Most notably he had his first meeting with Gauguin, just returned from the West Indies, who agreed to an exchange of pictures.

From his new-found isolation in Arles, van Gogh worked tirelessly to keep these contacts alive, corresponding with his friends almost daily. He

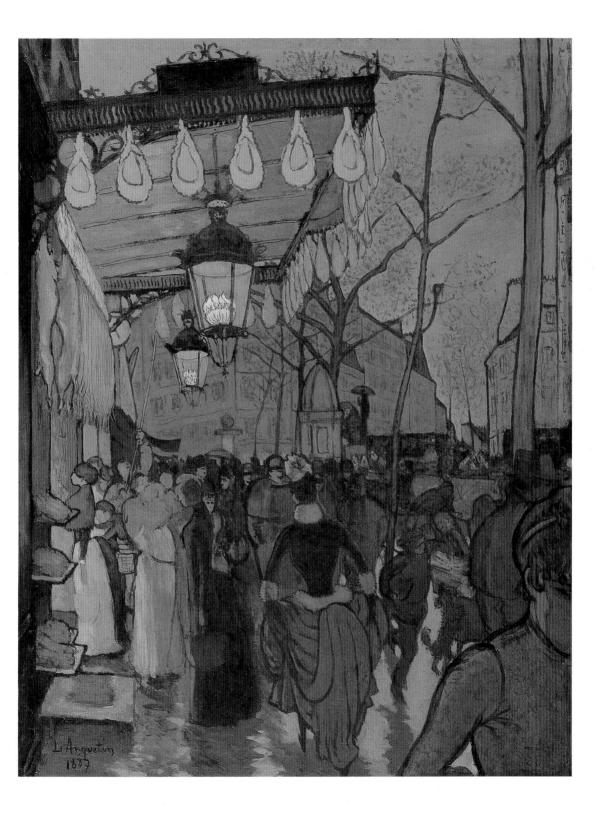

also acknowledged the importance of the new directions suggested by Anquetin's paintings which were widely exhibited over the next eighteen months: they were in the consignment the artist sent in February 1888 to the important independent group in Brussels, Les XX, and were also seen on three separate occasions in Paris. The new boldness and clarity entering van Gogh's Arles compositions that year, which include some his best-known paintings, can be traced back to the homage paid by van Gogh to both *The Reaper* and *Evening: Avenue de Clichy. Sunflowers* (fig.17) for example, one of a series of paintings with which he intended to decorate a room prepared for Gauguin's visit, is a japonist/cloisonnist harmony in golds, with the distinctive decorative shapes of the flower heads set in relief against the two bold flat background colours separated by a crude blue line.

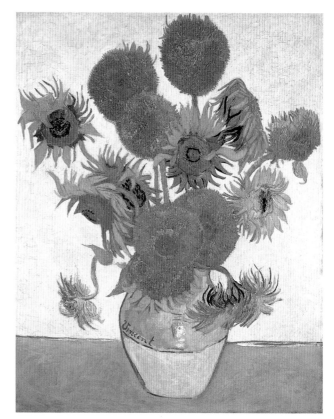

It was clear to most attentive visitors to the Grand Bouillon exhibition – among them Pissarro, Guillaumin and Gauguin – that the cloisonnist manner, analogous not only to stained glass (which is what had evidently inspired it) but also to Japanese prints, represented a stark contrast to the pointillist manner with its predominantly blond, vibrating tonalities. Immediately and prophetically, the naturalist author and critic Gustave Geffroy drew attention to this opposition when he entitled his review in *La Justice*, in February 1888, '*Pointillé-cloisonné*'. A new Post-Impressionist style had been born.

THE IMAGE OF THE ARTIST: GAUGUIN THE PRIMITIVE

For Gauguin, salvation from the doubts that beset him as an artist in the wake of the 1886 exhibition came from the stimulus of new places, and the experience of otherness engendered by voluntary displacement. Brittany was a popular haven for painters escaping the city and Gauguin, lodging in Pont-Aven, found himself surrounded by students as well as more established painters of a conservative academic stamp. He stood out as the revolutionary amongst them because of his known involvement with the Impressionists. Opposition of this kind suited him, helping him to settle on

his identity as an artist, an identity he explored exhaustively in his writing, painting and sculpture over the next three years. Brittany also brought him into head-on confrontation with the ideology of academic art for which he and the Impressionists had always expressed contempt and against which he would continue to rail throughout his career. He was now able to observe at first hand how academic realist methods were being put into practice, often with the aid of photographs, to produce the highly finished anecdotal confections that ensured popular success at the Salon. At the same time the elements of difference that attracted so many painters to this extreme corner of France proved more fruitfully suggestive to Gauguin than to those artists essentially just looking for picturesque local colour.

The need to preserve and record the social, cultural and religious differences that had traditionally marked off the people of Brittany from the fast-changing, increasingly secular world of Paris formed an important element in Brittany's popularity with painters. The contrast was made all the starker by the ease with which the railway now transported travellers from the heart of the capital to the depths of Finistère. Gauguin was at first slow to pick up on these endangered cultural indicators – costume, ritual, religious imagery – but on his second visit in 1888 he showed himself to be fully alert, just as he would later be in Tahiti. In the interim he had travelled to Martinique, where the first seeds of his enthusiasm for the primitive had been sown. He travelled there, by his own admission, to find reinvigoration and to distance himself from the frenzied struggle of artistic life in Paris. He was also in pursuit of exotic motifs whose novelty would whet the jaded palates of the picture-buying public. The adventure had the effect of reviving his memories of the wider world he had experienced both as child and merchant seaman, and he returned to France convinced that a rosy future lay ahead for the painter who was capable of exploiting the tropics, so recently opened up by colonisation.

In the mean time, he would capitalise on what Brittany had to offer, imbuing himself with the 'character of the people and the locality, which is essential if I'm to paint well', he argued in early 1888. To pursue this aim, as he explained to his wife from whom he had been separated for three years, he had had to dam up the emotional, sensitive side of his nature, and liberate the 'savage' side so it could 'advance resolutely and unimpeded'.

The idea that sacrifices had to be made in the pursuit of a higher goal permeated Gauguin's thinking in 1888, allowing him to condense his sensations of nature and achieve that radical simplification of painting style he had been pursuing for some time. After the fine weave of separate brush strokes that had characterised his paintings in 1887, he now began to paint more as he drew, using almost solid blocks of colour and clearly demarcating forms with strong contour lines. His drawing style had been developing along these lines for some time, influenced to a considerable degree by the synthetic linearity he observed in Degas and, when making a series of ceramic pots in Paris between 1886–7, he had realised the decorative possibilities of flat colour and curving line.

In view of his age, experience and inclination to hold court, a number of

17
Vincent van Gogh
Sunflowers 1888
Oil on canvas
92 × 73 (36¼ × 28¾)
National Gallery,
London

artists were now turning to Gauguin for advice and support; the same group would later earn the name Ecole de Pont-Aven, although it was never more than an informal artistic grouping. In this spirit the young Emile Bernard sought Gauguin's guidance that summer, having been urged to seek him out by their mutual friend Vincent van Gogh. The experience of advising and supervising a receptive younger pupil proved a vitally instructive one for the elder artist, just as it would do when he met Paul Sérusier a couple of months later. Bernard brought Gauguin into direct contact with cloisonnism which provided just the spur he needed. 'Young Bernard is here', Gauguin wrote to Schuffenecker, 'he's one who fears nothing'. The radically simplified cloisonnist paintings Bernard brought from Saint Briac and the compositions he subsequently produced in Pont-Aven, with Gauguin's encouragement, such as *Breton Women in the Meadow* (fig.18), served as pictorial demonstrations confirming some of Gauguin's slowly maturing theoretical ideas about expression and the need for a more reflective

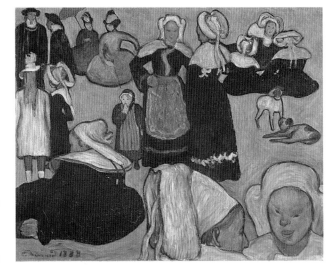

relationship between the artist and nature. Bernard's painting of Breton women treated the figures as simplified decorative shapes with only a vestigial reference to the logic of pictorial recession, the picture's composition held together by rhyming forms but by little or no narrative.

In letters to Schuffenecker and van Gogh, Gauguin discussed the technical questions and new pictorial possibilities opened up by cloisonnism. 'A word of advice, do not copy nature too closely', he recommended the former. 'Art is an abstraction'. In September 1888, taking his own advice, Gauguin executed the remarkable painting, *The Vision after the Sermon (Jacob and the Angel)* (fig.19), a complex exploration of the nature of Breton piety; it took him, literally, beyond the seen world into the realm of the visionary.

It seems probable that *The Vision after the Sermon* was painted in response to hearing a sermon preached by the local *curé*, and was an attempt to express something of the superstitious piety of the predominantly female Breton congregation. (Bernard and his attractive sister Madeleine were devoted church-goers which may have encouraged Gauguin to attend the services.) The forms of the praying women's faces, the focus of Gauguin's attention, are far more sculptural and sophisticated than in Bernard's painting. Yet Gauguin used similarly abbreviated contours to make the shapes of their coiffes stand out against the background, achieving a striking contrast between the decorative white shapes and the background of uniform, non-naturalistic red. This red was not made to suffuse the whole, to imitate a

dominant note or mood of nature as in Anquetin's cloisonnist works or van Gogh's recent experiments in landscape and still-life using a dominant yellow (for example, *Sunflowers*). Instead, as Gauguin explained to van Gogh, it had a purely symbolic significance: 'For me, in this picture the landscape and the struggle only exist in the imagination of the people in prayer, as a result of the sermon. That is why there is the contrast between the real people and the struggle in its unnaturalistic and disproportionate landscape.' Putting the final seal on his new conception of his artistic role, Gauguin added the face of the priest to lower right, giving him his own features. In so doing he was quite deliberately equating the artist's powers with the powers of the priest to transport his listeners, to create images in

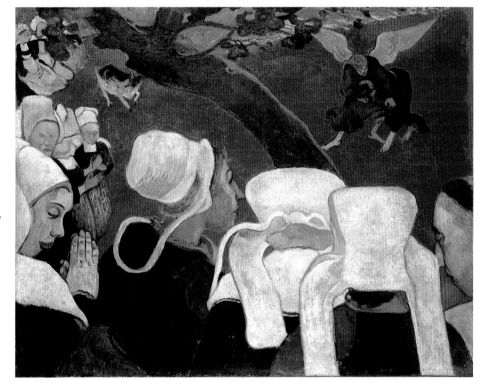

18
Emile Bernard

Breton Women in the Meadow 1888

Oil on canvas
74 × 92 (29¼ × 36¼)
Musée d'Orsay, Paris

19
Paul Gauguin

The Vision after the Sermon (Jacob and the Angel) 1888

Oil on canvas
74.4 × 93.1
(29¼ × 36½)
National Gallery of Scotland, Edinburgh

their minds. This heroic, transcendental analogy was one he would pursue over the following year in writings and images in which he successively cast himself in the role of martyr (fig.20), fallen angel or Christ himself.

Three years later, when *The Vision* was hailed by critics as Gauguin's first Symbolist masterpiece, Bernard claimed that its concept had been stolen from his own earlier painting. The accusation, made in a spirit of pique and jealousy when Bernard was still floundering and Gauguin's career was taking off, provoked a long-running dispute characteristic of the way in which the history of modernist art has been written, that is, setting more store by originality, by getting there first, than by sustained achievement. As other witnesses of the events in 1888 told a different story and Bernard's reliability

as a historian can frequently be called into question, it is difficult to ascertain the fair distribution of credit. Certainly Bernard's role was overlooked by critics of the time, notably by Gauguin's champion Albert Aurier, despite the contribution he had made in helping van Gogh find his personal style. What seems undeniable is that Bernard was himself the beneficiary and propagator of Anquetin's discoveries (as was Signac of Seurat's), and Anquetin's claim to being the originator of cloisonnism, which has only recently been properly re-established, goes unchallenged. The key question for the historian is what each artist made of this relatively simple stylistic idea over their career as a whole. Whereas both Anquetin and Bernard left behind their phase of cloisonnism, renouncing it as an

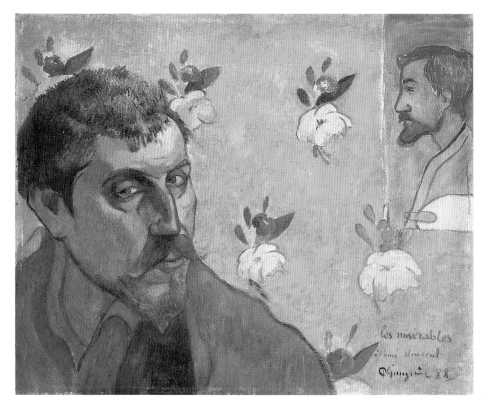

20
Paul Gauguin

Self portrait: Les Misérables 1888

Oil on canvas
45 × 55 (17¾ × 21½)
Van Gogh Museum, Amsterdam (Vincent van Gogh Foundation)

21
Paul Gauguin

Grape Harvest at Arles: Human Anguish 1888

Oil on canvas
73 × 92 (28¾ × 36¼)
The Ordrupgaard Collection, Copenhagen

aberration of youth (each turning instead to the exploration of more conventional, archaicising styles), van Gogh and Gauguin were able to take from cloisonnism, at a key point in their development, just those aspects they needed to simplify and refine earlier technical equivocations and complexities into a settled, mature style. The key to Gauguin's modernity is its eclecticism – his daring to pick and mix disparate cultural borrowings and personal memories – and it is this characteristic, rather more than his stylistic debt to cloisonnism, that has proved his enduring legacy for twentieth-century artists.

Van Gogh and Gauguin: Isolation and Group Activity

Any assessment of the dynamics of the Ecole de Pont-Aven has to take account of its honorary member, Vincent van Gogh. Despite never visiting Brittany, van Gogh kept abreast of, and even to a degree influenced events there. Certainly Gauguin's movements from 1888 on were made with an eye to the approval of his new dealer, Vincent's brother, Theo van Gogh, whose firm now allowed him some leeway to support contemporary artists. It was largely to please Theo that Gauguin left Pont-Aven in October 1888, at this highly creative period, to go and join Vincent in Arles. Their experiment in shared living and artistic collaboration, for which Theo footed the bill, was

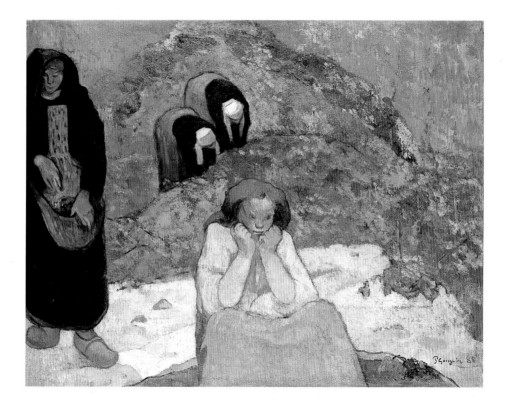

more productive of ideas for the future than of major works, although certain creative exchanges did occur.

Despite a degree of common ground, the two artists were as diametrically opposed in their approach to painting as they were to many fundamental moral questions. Gauguin brought to his painting a cool, calculating and elegant manipulation of colour and form, even when the themes were as emotionally charged and brooding as *The Vision after the Sermon* (fig.19) or *Grape Harvest at Arles: Human Anguish* (fig.21), both, of course, subjects of his own devising. He seems to have displayed something of the same ironic detachment in his dealings with the opposite sex. Van Gogh, conscious of his own relative inexperience in sexual matters, was wary of the

Frenchman's hypocritical attitudes, suspicious of his skill in the casuistic art of squaring up to his own conscience. The Dutchman's approach to painting too was more instinctive, emotional, sentimental and moral. It owed much of its energy and zeal to his Protestant background, which drove him along the road of salvation by deed through work, each picture

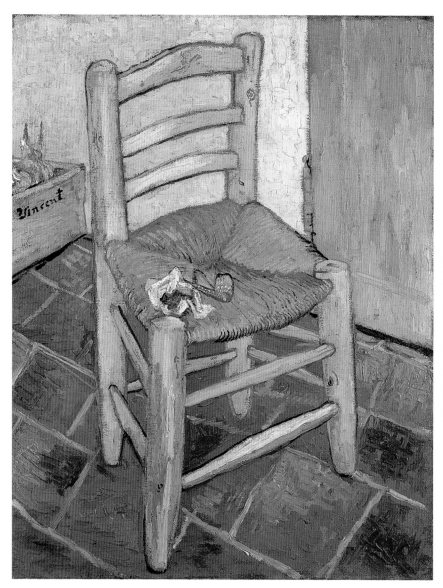

22
Vincent van Gogh

Vincent's Chair with his Pipe 1888–9

Oil on canvas
92 × 73 (36¼ × 28¾)
National Gallery,
London

23
Vincent van Gogh

Corner of the Garden of St Paul's Hospital at St Rémy 1889

Pencil and pen and ink on paper
62.2 × 48.3
(24½ × 19)
Tate Gallery

being a labour of love. It was art conceived, albeit naively, as a humble, accumulative activity that was essentially a homage to God's creation. The difference in the artists' attitudes helps to explain their very different approach to subject matter. Where Gauguin, as we see in figs.20 and 21, advocated synthetic compositions incorporating memory images and symbolic and multi-layered meanings (enabling him to incorporate

incongruities like the Japanese-style wrestlers in the *Vision*, or the Breton women in his grapeharvest scene), van Gogh's preference was for simple, self-contained, almost iconic motifs taken from nature, but seen through the filter of literature or earlier art and infused with his subjective feelings (*Vincent's Chair with his Pipe*, fig.22).

Following a visit to the Musée Fabre in Montpellier, Gauguin was able to put his finger on the opposing traditions to which the two owed allegiance: while they shared, with different emphases, an intense admiration of Delacroix, van Gogh belonged to a line of romantic/realist painters including Daumier, Ziem, Monticelli and Daubigny, whose painting techniques involved expressive but messy impasto; whereas Gauguin himself empathised with a more classical tradition of draughtsmen including Raphael, Ingres and Degas, where the emotion was disguised beneath the surface and the emphasis was on line and unemphatic colour. He believed

that it was this tradition which led logically to the primitive.

Van Gogh's already delicate state of mental health was not helped by the electricity generated by their discussions nor by his allowing himself to be swayed by the Frenchman's example to work solely from the ideas in his head rather than from external nature. Things came to a violent crisis late in December when van Gogh, trying to attack Gauguin, resorted instead to self-mutilation. Following this incident, van Gogh opted for voluntary hospitalisation and Gauguin returned to Paris.

It was perhaps forseeable that van Gogh would not manage to sustain such a close working relationship for long. Violent siezures of mental instability were to occur with increasing frequency, the precise cause of which has puzzled clinicians ever since his death. Two recent hypotheses are that he suffered from Menière's disease (an episodic combination of dizziness, nausea, variable hearing loss and tinnitus), or from acute intermittent porphyria (combinations of digestive and skin disorders, sensitivity to light and brain damage). Van Gogh's obsessional tendencies gave an extraordinary energy and strength to his work, as can be seen in some of his most beautiful drawings done in the asylum of Saint Rémy (fig.23), where the pattern-making pen marks work restlessly across the whole surface of the sheet. But these tendencies evidently came out in argument too, making him a dogmatic and inflexible companion. Nevertheless, such obsession enabled van Gogh to achieve enormous amounts of work in the short space of time left to him. His manner of working, impassioned and profligate, appalled Gauguin, for whom a certain parsimonious use of paint was dictated not only by taste, but, as has traditionally been the case, by economy. Cushioned from economic realities by his brother's subsidies, van Gogh had none of the artist's traditional regard for the need to eke out his materials, resulting

in the uniquely thick impastos that corrugate the surfaces of his canvases. It was this virtuoso aspect of his oeuvre and the colouristic freedom with which he animated his observations of nature (fig.24), more than his subjects, that were to constitute his legacy for his followers.

By 1888–9 Gauguin was convinced that as leader of a united group, it would be easy to mount a counter-attack on the influence of Seurat and Neo-Impressionism; he thus welcomed and engineered the recruitment of new acolytes. With van Gogh now recovering and working well, he was invited to take part, alongside Gauguin, Schuffenecker, Bernard and some of

Bernard's friends, in the *Impressionist and Synthetist* exhibition they had organised at the café Volpini, very much along the lines he himself had earlier pioneered and envisaged for the occasion. It was an opportunistic way of getting their work seen by some of the crowds visiting the Champ de Mars to marvel at the new Eiffel Tower and view the official art exhibition staged for the Universal Exhibition. In several critics' reviews Anquetin's works were represented as the most radical in the show; perhaps prudently, Gauguin had held back from showing *Vision after the Sermon* following the controversy it had caused in February at Les XX in Brussels. Van Gogh's

decision not to participate is difficult to interpret: was it a symbolic signalling of his disillusionment with the ideal of group endeavour by which he had formerly set such store, or a cautious reluctance to send out the wrong messages to the uncomprehending public, which his brother Theo seems to have advised that such an exhibition might do?

Ironically, despite the difficulties encountered by van Gogh and Gauguin in attempting to work together, and their equivocal attitudes to being exhibited side by side, it was when seen together that their works were to make the greatest impact on others: the first such occasion was the Les XX exhibition of 1891, where they were the two artists arousing the greatest clamour among the critics. The Irish artist Roderic O'Conor was one of the first to respond to the experience of encountering Gauguin and van Gogh's works in quick succession. In *Yellow Landscape, Pont-Aven* (fig.25), O'Conor's

24
Vincent Van Gogh

A Cornfield with Cypresses 1889

Oil on canvas
72 × 90.9 (28¼ × 35¾)
National Gallery,
London

25
Roderic O'Conor

Yellow Landscape, Pont-Aven 1892

Oil on canvas
67.6 × 91.8
(26¾ × 36¼)
Tate Gallery

vibrant palette and energetic drawing show what can only be described as a proto-Fauve excitement; similar effects would be displayed a decade or more later, when the examples of Gauguin and van Gogh again worked on the Fauves in France and the Bloomsbury and Camden Town groups in England.

Where van Gogh had been cast down by what he saw as irrevocable disunity in the Parisian avant-garde, the experience of seeing the works by Gauguin, Bernard, Anquetin and others at Volpini's offered hope of a new unity for a number of other artists, the foreigners visiting Paris such as de Haan, Verkade, or Willumsen, as well as a group of students at the Académie Julian already disaffected from their teachers, Paul Sérusier, Maurice Denis, Paul Ranson, Pierre Bonnard and Henri-Gabriel Ibels. According to the later recollection of Denis, what they saw in works such as

Anquetin's *Evening: Avenue de Clichy* (fig.16) was revelatory of a new attitude to nature and to the subject, less subservient, more liberated; brighter colours even than the Impressionists used; the forms of objects or figures distorted in order to heighten the decorative interest of the painting; above all not a shred of the illusionistic realism they had been taught to practise in the studios.

Sérusier took new courage from the Volpini exhibition. He had initially encountered Gauguin in Pont-Aven the previous October, at which time he had painted, under the latter's directions, the highly simplified, experimental work *Landscape in the Bois d'Amour (The Talisman)* (fig.26). He had even accompanied Gauguin on his abortive mission to donate *Vision after the Sermon* to the village church of Nizon where the gift was rejected by the *curé*, who suspected he was being made the butt of a practical joke. Sérusier, having

spent the winter in Paris, where his position of some authority at the Académie Julian added weight to the new message he had to impart, needed to be reassured that what Gauguin was about was sincere. The paintings and prints at Volpini's impressed him greatly and he returned to Brittany that summer and the next to join Gauguin's small band of followers in the village of Le Pouldu. There, they painted and discussed broad aesthetic questions, dividing their time between making synthetic paintings of the landscapes (fig.27) and decorating the dining room of the inn where they were lodging. Gauguin's personality dominated the gatherings and the heady atmosphere was one in which grand, Wagnerian undertakings could be hatched. Hence Sérusier wrote in 1889 to Maurice Denis: 'I dream for the future of a

26
Paul Sérusier

Landscape in the
Bois d'Amour
('The Talisman') 1888

Oil on board
27 × 22 (10¾ × 8¾)
Musée d'Orsay, Paris

27
Paul Gauguin

Harvest: Le Pouldu
1890

Oil on canvas
73 × 92.1 (28¾ × 36¼)
Tate Gallery

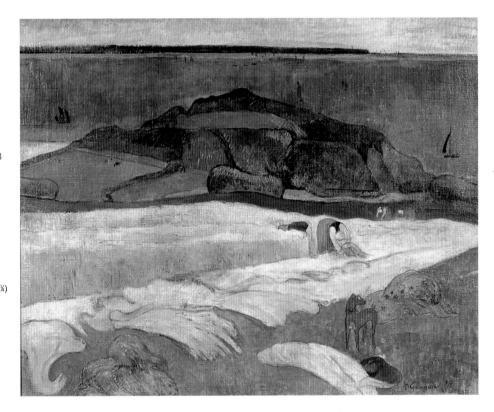

purified fraternity, made up solely of committed artists, lovers of the beautiful and the good, putting into their works and their way of life this indefinable character that I translate by the word "Nabi".' This arcane word, he had been informed, meant prophet in Hebrew, and had the right connotations of enthusiasm and elitism to set the newly constituted group on a different plane from their fellow students and the bourgeois public, the 'pelichtim'.

2

THE 1890s

THEORETICAL CONFUSIONS

By the beginning of the new decade, Gauguin was reasonably confident of his role as the only serious rival to Seurat's leadership of the avant-garde. The extraordinarily intense competition over stylistic innovation that had characterised artistic activity in the second half of the 1880s seemed to be running out of steam, although a similar heat began to be generated by the positions taken up in critical commentaries. While Seurat quibbled over the accuracy of Fénéon's articles in setting down the historical record concerning the paternity of Neo-Impressionism, anxious not to let too much credit go to Signac, Gauguin (whose thoughts were fixed on his plans to set up studio in the tropics) prepared to pass the baton to his intelligent new disciples, under the capable leadership of Paul Sérusier.

The Symbolist press, as we have seen, had begun to reflect upon the challenge to orthodox Impressionism presented by the paintings of Anquetin, Bernard and Gauguin – referring to them in a somewhat confused terminology as 'Impressionists', 'cloisonnists', 'synthetists' or 'Symbolists'. As part of an orchestrated promotion campaign to enhance the success of the sale of Gauguin's works at the Hôtel Drouot in February 1891, Albert Aurier would write an important article promoting Gauguin as the prime exponent of 'Symbolism in painting'. Appearing in the relatively mainstream, newly relaunched *Mercure de France*, this article not only started a long-running debate about pictorial Symbolism, it also provoked the

28
Pierre Puvis de Chavannes

Pleasant Land (Doux Pays) 1882

Oil on canvas
230 × 300
(90½ × 118)
Musée Bonnat,
Bayonne

embittered reaction of Bernard, and anger and disbelief in Gauguin's former mentor, Camille Pissarro, who fulminated to his son Lucien about Aurier's specious argument. One could not draw such a hard and fast distinction between Impressionism and Symbolism as Aurier had done, he argued, and in any case the critic had been completely hoodwinked by Gauguin: 'Gauguin is not a seer, he's a schemer who has sensed a reaction among the bourgeoisie away from the great idea of solidarity that is germinating among the masses – an unconscious idea, but a fruitful one, the only idea that is legitimate!' Pissarro's words highlight growing fears about the conservatism at the heart of the Symbolist doctrine, particularly in its reinstatement of the notion of the ideal. They also reflect the anarcho-socialist beliefs which Pissarro shared with many of the Neo-Impressionists and their supportive critics, if not with Seurat himself, ideas that gave them common cause quite as much as Seurat's novel, quasi-scientific technique. Broadly speaking, the anarchists were working towards a new order in which the old invested interests of wealth and power would give way to an egalitarian, co-operative society. This utopian cause had its extremists who, on several occasions in the 1890s, resorted to violence against political figures.

The clearest defence of Gauguin and exposition of the new ideas came from the ardent young Nabi painter, Maurice Denis, fresh from passing his baccalauréat in philosophy. In August 1890 the small Symbolist review *Art et critique* published his article under the portentous title 'Definition of Neo-

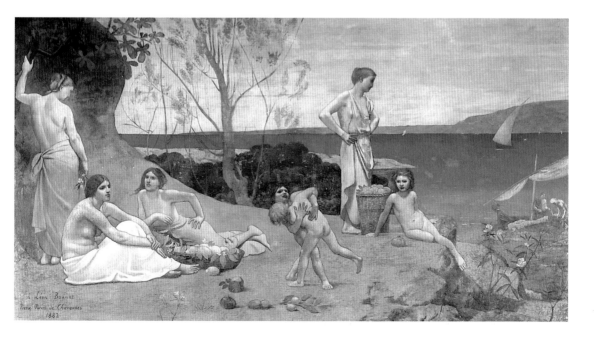

Traditionism'. It opened with a stirring phrase that captured in a nutshell the formalist direction in which innovative art was tending, in theory at least: 'Remember that a painting, before it is a war horse, a nude woman or some anecdote or other, is essentially a flat surface, covered in colours arranged in a certain order'. Denis claimed his motivation for writing the piece was to defend Gauguin, the dominant personality of Neo-Traditionism; it was also a way of clarifying for himself and presenting to others the synthetist ideas he had absorbed in dialogue with Sérusier. Denis stressed the importance for contemporary artists to seek to continue what he identified as a highly respectable anti-realist tradition in art, a tradition that was expressive, decorative and Symbolist in character and particularly associated with religious art. He argued that within this alternative tradition (which one might characterise as a kind of Pre-Raphaelitism, more broadly, synthetically conceived) Egyptian wall paintings and the frescoes, altarpieces and predellas of Italian quattrocentists such as Fra Angelico were linked to the easel paintings of contemporaries like Gauguin or the mural decorations of Puvis de Chavannes. Placing Puvis alongside Gauguin as beacons of hope, Denis urged his fellow artists to follow their lead and renounce the realist styles then ubiquitous in the offical Salons and teaching academies.

Puvis de Chavannes was an artist whose reputation had remained untainted by the general picture of debasement into which official art was judged to have sunk; he was the exception who proved the rule. Now nearing the end of his career, over the years he had received regular commissions to paint decorations for the walls of the Third Republic's public buildings. It was their shared enthusiasm for Puvis' broadly conceived style of patriotic elegance and restraint, well illustrated by his decoration on an arcadian theme, *Pleasant Land* (fig.28) – a work equally admired by Seurat and Signac – that sealed the comradeship between Nabi artists Denis and Vuillard. Like that of Gauguin, through the course of the 1890s Puvis' reputation was to rise and rise.

29
Vincent Van Gogh
Farms near Auvers
1890
Oil on canvas
50.2 × 100.3
(19¾ × 39½)
Tate Gallery

DEATHS AND REGROUPINGS: 1890–1

The new decade offered a chance for opposing factions to take stock and even, temporarily, to bury the hatchet, an obligation imposed by the abrupt disappearance from the scene of several of the dominant personalities and key innovators of the past few years. In July 1890, a few weeks before the appearance of Denis' articles, the avant-garde heard that Vincent van Gogh, aged only thirty-seven, had taken his own life in Auvers, a village to the north of Paris where he had been staying and working under the supervision of Dr Gachet (fig.29). His brother Theo, who had done so much to support Vincent and to promote the Impressionists and Gauguin, was struck by what seems to have been a related condition and died in January 1891. Vincent's death had been preceded by that of Albert Dubois-Pillet, a founder member of the Indépendants and one of Seurat's long-standing

Neo-Impressionist supporters. In 1891, the Salon des Indépendants staged memorial exhibitions to both artists, but a shadow was cast over these by news of the sudden death from illness of Seurat himself, aged only thirty-one. These first losses quickly came to be heroised as the martyrs of the new movement in painting.

The personal blow to Signac in particular, who had lost three close colleagues in the space of a year and upon whom much of the burden of organising memorial exhibitions fell, was devastating. We have no record of Gauguin's reaction to the news of his rival's death only days before his departure for Tahiti, but he certainly regarded the death of Theo van Gogh as a disaster for the successful realisation of his plans. For years to come he would continue to lament the lack of a courageous financial backer such as Theo van Gogh might have been, blaming upon this misfortune the fact that, instead of being able to reap the rewards of his speculative journey to

the South Pacific, his return visit to France in 1893 proved a failure, forcing him to see out his days in penury in the South Seas.

Something of the cohesion of the avant-garde was lost during the 1890s, partly due to the absence of the figureheads of the 1880s, but also as a result of a more widespread geographical fragmentation. Although no-one had been prepared to risk the colonial venture with Gauguin, many young artists who had spent periods studying in Paris opted, like van Gogh before them, to distance themselves from the capital with its heady but potentially confusing cauldron of conflicting ideas and the somewhat backbiting atmosphere it engendered.

For Paul Signac, strongly committed to the same progressive, anarchist views as Pissarro, Paris had definitely lost its charm. Living there, the ills of modern industrial society were conspicuous and oppressive. While he was to continue to play an influential role as president of the *Indépendants* group,

and as teacher and theorist of Divisionist colour practice, he preferred to work away from the capital. Cushioned by private means, Signac went first to Brittany, then, in 1892, to the south of France, in search of a setting in which to combine painting with his keen interest in sailing. He found the perfect combination in the small fishing harbour of Saint Tropez, as yet remote and unknown to tourism. In his wake, one after another of the Neo-Impressionists discovered for themselves the manifold attractions of the Mediterranean: the brilliant clarity and colouristic effects of sunlight, the unspoilt coastline scenery, the calm and traditional way of life close to nature. 'Let's not fuss about the slightly stiff aspect of our technique', Signac advised the newly recruited

Divisionist Henry Edmond Cross in 1892. 'It presents so many other advantages. Besides isn't it a philosophical method rather than a technique? Logic taken into the realms of the pure, the beautiful.' In the Midi, Signac and Cross found it possible to nurture the anarchist dream of a more harmonious future for society, which they paralleled in the search for harmonious beauty, but this necessitated abandoning the struggle to paint directly from the motif. 'It's extremely difficult to paint perfectly from nature', Signac observed in the same letter, 'one is distracted from one's harmonies by the merest reflection, the merest change of effect that one wants to record.' Such concerns for harmonious vision, together with a more decorative, mosaic-like touch gave a new classical order to later Neo-Impressionist compositions (for example, Signac's *Red Buoy, Saint Tropez*, fig.30), whose unrealistic pastoral vein

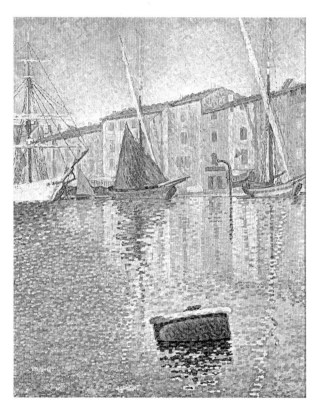

was to prove immensely appealing to the Fauves.

In addition to the South, Brittany continued to exert a strong pull particularly on the artists who had dealings with Gauguin. For Emile Bernard, Sérusier, Denis and new recruits to synthetism like Jan Verkade and Charles Filiger, motifs from modern urban and rural life were spurned in favour of the rugged landscapes and traditional scenes of rural labour and piety still to be found in France's ancient Celtic kingdom (fig.31). As well as Pont-Aven, new sites such as Huelgoat in central Brittany and Perros-Guirec on the north coast attracted summer devotees. Some of the Nabis were also drawn to Italy, to study in its proper setting that 'pre-Raphaelite' Italian art

Denis had spoken of in his articles. From there, Verkade and the Dane Mogens Ballin followed their conversion to Catholicism by specialising in religious mural decoration. The same desire for aesthetic discipline which underlay the Neo-Impressionists' investigations into science and colour division led these artists to a continuing preoccupation with religion and spirituality and, in Sérusier's case, to a sustained attempt to codify rules for composition and colour harmony.

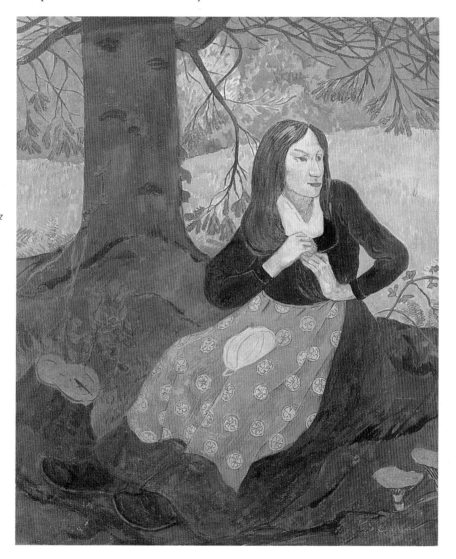

30
Paul Signac

Red Buoy, Saint Tropez
1895

Oil on canvas
81 × 65 (32 × 25½)
Musée d'Orsay, Paris

31
Paul Sérusier

*The Removed
Headdress* 1891

Oil on canvas
71 × 58 (28 × 23)
Josefowitz Collection

THE COMMERCIAL SUCCESS OF THE NABIS: DENIS, VUILLARD, BONNARD

Paul Sérusier was not only the initial driving force behind the idea of the Nabi brotherhood, he was also the only one to have had direct working contact with Gauguin in Brittany. Sérusier's teachings counted for much in the group's early stages, and his decision to stay on in Brittany, rather than assume a more active role as leader of the Nabis in Paris accounts, to a large extent, for the group's fragile and short-lived unity. To talk of a Nabi style is not really feasible, since there were marked differences in their manners of painting and preferred subjects from the beginning and, despite the efforts of Denis, no imposed group doctrine beyond a respect for individual talent. All, for a time, followed the prescriptions advocated by Sérusier, adopting a severe simplification of drawing and colour, experimenting with firm

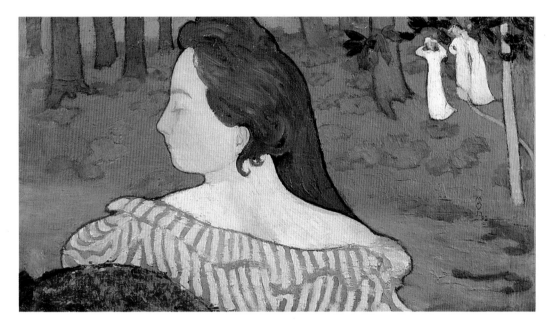

cloisonnist, caricatural or arabesque linearity and with the varied effects to be achieved by carefully balanced colour harmonies of no more than three or four different colours. The Nabis were greatly helped in this respect by their close study of Japanese prints. The need for control and completion was uppermost when, in 1892, Sérusier spoke to Verkade of drawing: 'each line should be deliberate and have its particular expressive and decorative role within the whole.'

In Denis' early works we see him experimenting in just this way, with synthetic line and controlled colour harmonies, often preferring subtle secondary colours – pinks, olive greens and oranges – to the cruder primaries. His natural inclination towards an unemphatic, Gauguinesque paint handling did not preclude the occasional use of decorative pointillism, and he favoured subjects with a religious, poetic or literary reference such as *Belle au bois d'automne* (fig.32). Using a similar variety of

techniques though with a more painterly touch, Bonnard and Vuillard preferred the subjects of modern daily life, particularly the scenes observed within their families.

In an 1892 review article Denis drew attention to the astonishing artistic revolution that had occurred in the short interval between the execution of Seurat's *Grande Jatte* (fig.7) and Emile Bernard's *bretonneries* (fig.18), a revolution whose 'subversive theories' were still providing the main stimulus and direction for his own contemporaries. It is a moot point whether the drama and compression of innovation of the previous few years were actually responsible for the more measured pace and reflective approach of this new offshoot of the Parisian avant-garde. As the Nabis embarked upon their careers, they were absorbing and building not only on these years of conflict and experimentation in the avant-garde but also on twenty-five years

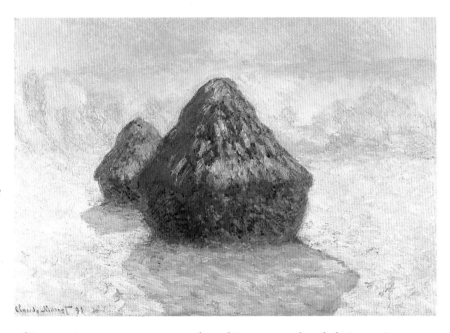

32
Maurice Denis

Belle au bois d'automne 1892

Oil on canvas
25 × 44 (10 × 17¼)
Private Collection

33
Claude Monet

Haystacks, Snow Effect 1891

Oil on canvas
64.8 × 92.1
(25½ × 36¼)
National Gallery of Scotland

of Impressionism, a movement whose history was already being written (G. Lecomte's *L'Art Impressionniste* was published in 1892). This undoubtedly armed them against some of the pitfalls experienced by their predecessors, and possibly accounted for their readiness to compromise. As a pointer to the steady rise in Impressionism's public status they could look to Claude Monet, whose marketability was always a little ahead of that of his colleagues. By 1890 Monet's paintings were selling so well in the United States, that his dealer Durand-Ruel decided to launch *L'Art dans les deux mondes*, a kind of art-trade journal, to further stimulate the New World collectors' progressive tastes. In such a climate there was no harm in reminding people of how different things had once been, by publishing Monet's poignant letters of hardship written to Bazille in the 1860s. Monet was now free from want, free to pursue the experimental new approach to the natural motif that had been emerging in his practice since the later

1880s: the idea of working by series. In 1890–1 he devoted himself to the stark, uncompromising motif of haystacks, observing how they changed at different times of day, under different weather conditions (fig.33); later he turned his attention to the façade of Rouen Cathedral.

Monet's early letters spoke essentially of economic struggles, but when the first samples of van Gogh's remarkable and voluminous correspondence began to appear in the press in 1893 (Bernard having decided to publish the letters he had received), it was even possible to relive the artistic struggle to achieve synthesis and an expressive use of colour that had been played out within his circle only five years before.

In comparison with the hostility and incomprehension encountered by the early Impressionists, or indeed van Gogh, the Nabis had an easy start, helped by receptive and influential friends. Denis' school friend Lugné-Poe, a rising star of the Symbolist theatre, took it upon himself to promote his painter friends, egging them on to exhibit their works: 'My friend has

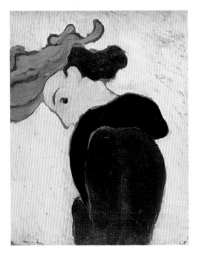
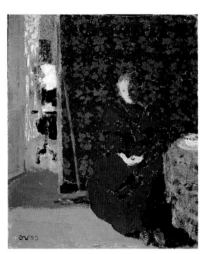

34
Edouard Vuillard

Woman in Profile with Green Hat 1890–1

Oil on cardboard
21 × 16 (8¼ × 6¼)
Musée d'Orsay, Paris

35
Edouard Vuillard

Seated Woman 1893

Oil on cardboard
25.4 × 20.3 (10 × 8)
Fitzwilliam Museum, Cambridge

36
Pierre Bonnard

The Two Poodles 1891

Oil on canvas
36.3 × 39.5
(14¼ × 15½)
Exh. Salon des Indépendants 1892
Southampton Art Gallery

spoken about us in his theatrical way, up and down the boulevard', Denis reported to Sérusier in 1890. 'People who have only just about heard of Anquetin and Signac are saying "Where are they?"' Following Gauguin's example the Nabis recognised the necessity of courting the media, of cultivating wealthy patrons and clients. As early as 1891, Denis' and Bonnard's exhibitions at the Salon des Indépendants having been successfully brought to key critics' attention, a well-funded dealer, Le Barc de Boutteville, came forward offering to mount a rolling display of their works in his small but well-placed shop in rue Le Peletier. They were also interviewed for the daily paper *L'Echo de Paris*. Their acceptability was due in part to their coming across as reasonable, well-brought up individuals – educated, intelligent young men familiar with the Louvre – and in part to the delicate charm and humour in their works.

Although the Paris-based Nabis did not lack for energy, conviction and jostling ambition, they were not, by nature or inclination, rebellious or political (with the exception of Ibels), and by and large each developed his

own style in his own way. In the early 1890s we see them trying to assimilate the new ideas into their practice, often, despite the difficulty involved, with extraordinarily daring results. But each of them first had to discard the naturalist precepts he had been taught. Notes in his diary relate how Vuillard in particular struggled with the requirements of synthetist simplification which so contradicted the more detailed realism achieved by the earlier masters, such as Chardin and Rembrandt, to whom he naturally gravitated. More or less overnight he began to experiment with bold, flat colour areas, at times demarcating them by a firm line, or alternatively allowing just a slight halo of untouched buff-coloured support to mark an edge; yet he also quickly reinstated the close-toned, distinctly non-Impressionist palette of earth colours and greys that was more in accord with his temperament. To achieve such radical simplifications of vision as *Woman in Profile with Green Hat* (fig.34) he made himself concentrate on the 'emotion' the subject produced in him, forcing himself to ignore peripheral details.

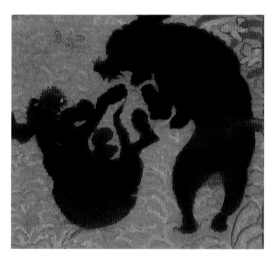

Bonnard and Vuillard, the two most naturally gifted of the Nabi group, briefly shared a studio in 1891. The works they produced thereafter have a certain similarity. In repeated studies, usually painted on cardboard, they succeeded in keeping in line with the synthetist prescriptions of Sérusier and Denis, yet remained in touch with the alert observations of moments in daily life that triggered their creative impulses. In *Seated Woman* (fig.35) for example, Vuillard does no more than encapsulate a chance glimpse of his sister and mother (the barely distinguishable bright form through the open doorway), captivated by the novel combination of light, dark and decorative pattern enfolding the contrasting figures. Bonnard's early experimental paintings revealed his fascination with Japanese mannerisms and arbitrary arabesque patterning, and, by their deliberately quirky choice of motif and selection of viewpoint, quickly gained him the reputation for humour that was to be a defining characteristic (*The Two Poodles*, fig.36).

Compared to the do-or-die extremism of their predecessors, the Nabis' demands for art and their conception of the artist's role were mild and reasonable; although initially fired by idealism, they were quick to achieve a more balanced accommodation between art and life. Many artists in the 1880s had gone out of their way to tackle difficult subjects, whether in the urban sphere or via the primitive; a vein of frank and sometimes sardonic realism persisted in the 1890s, particularly in the work of Toulouse-Lautrec, fascinated by the marginal existences lived by café entertainers and prostitutes (figs.37, 38). Although they exhibited alongside Lautrec, the Parisian Nabis, dubbed 'intimists', drew their inspiration from closer to home. Vuillard was touching upon more than a personal insight when he

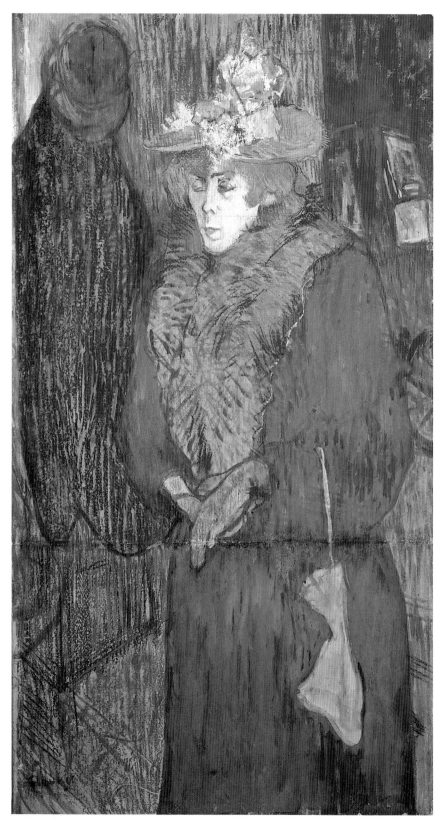

37
Henri de Toulouse-Lautrec

Jane Avril Entering the Moulin Rouge 1892

Oil on pastel on board
102 × 55 (40⅛ × 21¾)
The Courtauld Gallery, London

38
Henri de Toulouse-Lautrec

The Two Friends 1894

Oil on board
47.9 × 34 (19 × 13½)
Tate Gallery

asked himself: 'Why is it always in the familiar places that the mind and the sensibility find the greatest degree of genuine novelty?' By 'familiar places' he essentially meant the rooms of his apartment or the streets and squares of his local *quartier*. But by 'genuine novelty' he surely meant something intrinsic to the artistic process and to his own very new way of seeing.

ART NOUVEAU: FIN DE SIÈCLE

Of course, like the 1990s, the 1890s was a self-consciously *fin de siècle* decade, which saw both aesthetic and moral questions brought to the forefront of contemporary debate. In France, the rise of Art Nouveau, a non-native movement, was strongly influenced by ideas originating in her more industrial neighbours, Britain, the Low Countries and the Rhineland. Art Nouveau was, in some ways, a reactionary attempt to close the widening gap

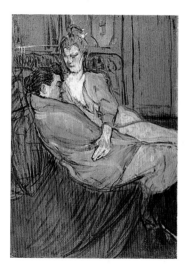

between craft practice and mechanisation, nature and science; the socialist element within it, deriving from the ideas of William Morris, was also strong. Art Nouveau introduced a mania for tasteful design and exquisite *objets d'art*. The decorative arts, no longer deemed inferior, were increasingly exhibited in the same contexts as the fine arts of painting and sculpture. Such a development gave new outlets for craftsmen, but also opened up new possibilities for progressive painters (possibly distracting them at a crucial moment from the more serious activity of easel painting; this at least was how it looked to the older generation, including Pissarro and Degas). The Nabis applied their artistic ideals to practical ends, designing stage sets and costumes, wallpapers, posters, book and music illustrations, furniture and ceramics; and this accommodating versatility was perhaps the reason they were so soon afforded the opportunities missed by their predecessors, namely to paint large-scale decorations to hang on the walls of Parisian apartments.

In addition to the ubiquitous *fin de siècle*, the other key watchword of the 1890s was Symbolism. Very much of their time were the Salons de la Rose+Croix in Paris, held between 1892 and 1897 and initially sponsored by Durand-Ruel who allowed his galleries to be used for the first exhibition; it was here that the talented Swiss artists Félix Vallotton and Ferdinand Hodler first came to critical attention. Participation was by invitation only, with artists having to meet the stringent criteria laid down by the self-styled Grand High Master of the Rosicrucian order, Sâr Joséphin Péladan. Briefly, these stipulated that 'Art' should rise above the banal realities of daily life and set its sights on lofty idealised subjects. Although a number of Pont-Aven and Nabi artists met the criteria and were asked to exhibit, the fact that most chose to steer clear of Péladan's Salon, put off, as much as anything, by Péladan's autocratic style, marked a growing tendency to sectarianism within the broad church of Symbolism. Henceforth, artists

committed to formal and stylistic innovation and synthesis dissociated themselves from the growing number of Symbolist artists who were stylistically more conservative, even academic; artists who had learned nothing from Impressionism but were fascinated by the more effete, decadent aspects of the symbol.

In their instinctive recoil from the decadent strands within Symbolism, Signac and Denis, rival spokesmen and theorists for Neo-Impressionism and Neo-Traditionism respectively, were on common ground. Despite their approach to art from diametrically opposed ideological positions, Signac as a committed anarchist, Denis as a right-wing Catholic, they considered it preferable to exhibit in each other's company than rub shoulders with the academic Symbolists and Rosicrucians. Indeed, Symbolist and Neo-Impressionist works were, on several occasions, hung side by side at Le Barc de Boutteville's gallery, and in 1899 the rival groups came together in an important demonstration of avant-garde unity at Durand-Ruel's gallery. Where they concurred was in their belief in the primacy of formal means and artistic sincerity over moral or propagandist ends. 'The anarchist painter,' wrote Signac, 'is not one who will paint anarchist subjects, but one who, with no concern for lucre, no desire for recompense, will struggle with his whole being against bourgeois and official conventions using what he can bring in personal terms. The subject is nothing, or at least is only one of the aspects of the work, of no more importance than the other elements, colours, drawing, composition'. In their respect for individualism, and their search for an ordered harmony, Signac and Denis had arrived, for a time, at a remarkable accord in their working methods and aesthetic aspirations.

39
Félix Vallotton

Nude Seated in a Red Armchair 1897

Oil on canvas
30 × 29 (11¾ × 11½)
Musée des Beaux-Arts, Grenoble

FRAGMENTATION OF THE NABI BROTHERHOOD

By 1895, Sérusier was beginning to lose faith in the sustainability of his original idea of an artistic brotherhood. He complained to Verkade that the communal effort he had envisaged when he proudly named his friends the Nabis had been lost along the way: 'the search for personality, a journalistic invention, has dispersed all that fine force.' He despaired of getting the more sceptical of his fellow Nabis to accept his own firm conviction that there were absolute rules of beauty whose secrets lay undiscovered in mathematics and geometry, and he began to wonder whether the search he had undertaken was a vain one. Maurice Denis, although he kept faith with Sérusier's intellectual undertaking, addressed their perceived shortcomings of hesitation and incompletion in a different way. In the early years, all the Nabis had been criticised for showing too many small, half-formed works, fragments that promised much but were judged to be little more than charming effects, still at the embryonic stage. Denis now felt it was incumbent upon them all to achieve a more complete resolution in their paintings. In 1898, in order to achieve a better understanding of the perfection and completion of Renaissance art, which his early theories had treated as suspect, he subjected himself to the lesson of Raphael in Rome. Guided by André Gide, Denis

revised his former thinking, arriving at a conviction of the importance of classicism from which he would never really waver. Keen to share his discoveries with Vuillard, he urged his friend to try, as he did, to produce more resolved compositions. Vuillard argued that the idea of an imposed method or system was anathema to him, and he clung obstinately now, but with self-knowledge, to the notion of sensation, to the direct, albeit incomplete, emotional response to the thing seen, which in essence, as far as he was concerned, was the legacy of Impressionism.

By the end of the decade a clear division in the group was becoming

apparent to Denis in which he ranged himself, Sérusier and Ranson on one side, striving by more intellectual means to realise complete works of art, and, on the other, the more instinctive painterly members, Bonnard and Vuillard, who together with the coolly ironic Vallotton (fig.39), were guided by their emotional sensibilities. Yet it was a division that had as much to do with personal and political allegiance as with aesthetic concerns. Vuillard, together with Bonnard and Vallotton, had been drawn increasingly into the social and artistic orbit of *La Revue blanche*, a monthly journal run by the Jewish Natanson brothers. The target reader of *La Revue blanche* (who was

more or less synonymous with the typical buyer of these artists' works) may be characterised as the satirical, free-thinking, anarchist-sympathising man-about-town, not a profile that accorded too well with the reactionary Catholic adherent of Neo-Traditionism. It is no coincidence that Denis and Vuillard found it impossible to agree about artistic questions at this time, painfully polarised as they were by the Dreyfus Affair, a soul-searching dilemma that split France in two and had ramifications for the artistic debate. Evidence was mounting to indicate that in 1894 a profound miscarriage of justice had condemned the Jewish officer Captain Dreyfus of spying for the Germans in 1899. Vuillard reluctantly signed *L'Aurore*'s petition pro-Dreyfus, knowing Denis would be signing *La Libre Parole*'s against.

The examples of Signac and Denis show that political divides did not necessarily find expression in artistic opposition; nevertheless their respective beliefs mirrored the extreme polarisations of the 1890s. On the one hand, revolutionary anarchists called for the overthrow of government; on the other, reactionary patriotic forces rallied in support of the old triumvirate of church, army and monarchy. It was this reactionary wing of the bourgeoisie whose allegiance Pissarro had accused Gauguin of deliberately courting. Such political differences, normally unspoken within artistic circles, were brought into the open by the protracted and tortuous Dreyfus Affair. In its wake, nationalistic arguments began to frame art criticism: there was a growing tendency to identify the synthesis and breadth achieved by artists such as Puvis, Degas or Gauguin as an intrinsic and pure French trait whose origins lay in a Latin classical tradition; while a niggling obsession with detail and finish was seen as typical of the English schools; complex, complicated textures and bejewelled surfaces, however, were identified as appealing to Jewish taste. Such opinions crop up repeatedly in the writings of Denis and others around 1900. Denis' promotion of classicism was partly in order to quash what he saw as the unhealthy foreign elements within Symbolism (associated with artists like Whistler and Burne-Jones), and to offer a corrective discipline to the rampant individualism and unmethodical sensualism that he saw all around him. In subsequent years, for all his admiration of their talents, and reluctance to lose their allegiance, Denis could not disguise the fact that he was increasingly bemused by Bonnard and Vuillard's lack of solid method.

As the group mentality lost its hold on the Nabis, individual members began casting around for like-minded mentors among their seniors. Denis made a point of researching the methods of Degas, Cézanne and Maillol (whose reactionary politics agreed with his own), bent on fitting them, alongside Gauguin, into his artistic and theoretical pantheon; Sérusier was drawn to the teachings of Father Desiderius at Verkade's Benedictine monastery of Beuron. Vuillard and Bonnard, always somewhat sceptical of Gauguin, left behind the starker synthetic approach of their youth, to explore the plenitude of their range as touch painters and colourists, and gravitated towards the elder Impressionists, Monet and Renoir, whose natural heirs they seemed to be.

40 Paul Cézanne

Le Lac d'Annecy 1896

Oil on canvas
65 × 81 (25½ × 32)
The Courtauld Gallery,
London

**41
Paul Cézanne**

Still Life with Water Jug
c.1892–3

Oil on canvas
53 × 71.1 (21 × 28)
Tate Gallery

**42
Maurice Denis**

Homage to Cézanne
1900

Oil on canvas
180 × 240 (71 × 94½)
Musée d'Orsay, Paris

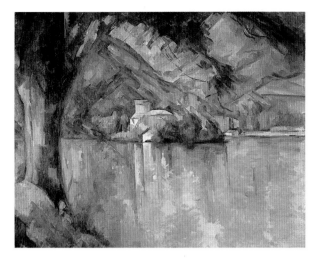

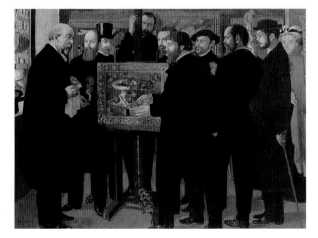

Neo-Impressionism versus Cézannism

1899 saw the publication of Signac's manifesto pamphlet, *D'Eugène Delacroix au néo-impressionnisme*, dedicated to Seurat. Its appearance, at a time when the movement's influence exceeded its cohesion, gave a much-needed theoretical underpinning to the scientific system of colour division. It also set Neo-Impressionism within its own colourist tradition whose lineage included Delacroix, Turner and Constable, Jongkind and the Impressionists and, significantly, Cézanne. For the talented group led by Matisse, soon to make their presence felt as the Fauves (wild beasts), in the Salon des Indépendants and the new Salon d'Automne, Signac's book was to prove a vital document, which they read in parallel with the persuasively reasoned articles of Denis.

Denis' urging for classicism was in tune with a more general literary and artistic interest in France's Latin and classical roots. Such interest coincided with, and prepared the terms for, the return to prominence of Cézanne who, having, for so many years, been an enigma to the younger generation (they knew him only through his works, seen at the shop of the colour merchant, Tanguy, in Montmartre), was suddenly, in 1895, revealed to them in strength at a one-man exhibition organised by Ambroise Vollard. Although the exhibition seems mainly to have consisted of small-scale paintings and watercolours, these confirmed the views of those who had admired Cézanne for years (most of the Impressionists bought one or more works), and won over a new

enthusiastic following. Over the next decade or more admirers and collectors from France and abroad would make the pilgrimage to Vollard's gallery to see Cézanne's masterly landscapes, bathers and still lifes (figs.40, 41).

In anticipation of his intense investigation into Cézanne's methods in the 1900s, Denis drafted his fellow Nabis into a curious manifesto group portrait, *Homage to Cézanne* (fig.42), which he exhibited on two occasions in 1901 and sold, aptly, to Gide. The image it portrays of an artistic solidarity and alliance is both nostalgic and somewhat anachronistic. A true image of Cézanne's supporters around 1900 would necessarily have included many others in the gathering in Vollard's boutique. One notable absentee is Emile Bernard. In fact the grouping of most of the Nabis there, with Odilon Redon on the left, is only explicable by the fact that the painting was originally planned to mark the honourable esteem in which Redon was held by the younger artists, a last isolated representative of the power of imagination in art (fig.43). Indeed, Redon's warm encouragement of their varied efforts as individuals afford a welcome change from the somewhat rueful and embittered neglect they had received from Gauguin, whose absent presence nevertheless figures in the painting, in the colourful canvases on the gallery wall.

Despite its oddities, however, Denis' painted homage served its purpose in alerting Cézanne to his growing importance for the younger generation. Warmed too by the encouragement of his old Impressionist comrades, Cézanne, in spite of himself, seems even to have welcomed the contact brought upon him by critical acclaim with those younger artists who dared to penetrate his solitude in Aix-en-Provence. At different dates he received, first Bernard, and then Denis and Roussel. Denis was delighted to find that his own high estimation and trust in Cézanne's significance had not been misplaced: 'He talks very well, he knows what he is doing, what his own value is, he is simple and very intelligent', Denis wrote to his wife after his first meeting with Cézanne in 1906. One of Cézanne's truisms recorded by Denis at this time, that Gauguin had so wished to hear two decades earlier, was this: 'Light is not something that can be reproduced, it must be represented by something else, by colours.'

THE NEW CENTURY: OPTIMISM AND PESSIMISM

As we approach the end of the millennium alarm bells are regularly sounded regarding the downside to the undoubted benefits Western society has gained from material and technological progress. Similar disillusion with the political idea of progress and loss of faith in the scientific model of thought was frequently encountered in the 1890s, particularly in advanced art and literature. In France the Symbolist poets, inheriting the philosophical outlook of Baudelaire and the Decadents, turned aside from the marvels or horrors of the age of science and its social and democratic upheavals, to focus inwards upon the human soul or to look back nostalgically on a pre-existing ideal time of harmonious relations, whether between the sexes or between man and nature. In art, a similar impulse lay behind various efforts to turn back the clock, to retrieve the simplicity and sincerity of a 'primitive' era before science had triumphantly proclaimed the whole of the visible universe to be within its grasp, in the form of anatomy, optics or photography, and before standardisation in industry had crushed all individuality from the productive process.

Extreme disenchantment with the modern world was a strong part of what led van Gogh to Arles, or Gauguin to seek refuge in what he imagined to be the untainted, restorative paradise of the South Seas. But coupled with it was the calculated, opportunistic commercialism that weakened Gauguin's case in the eyes of his contemporaries, just as his exploitative sexism and colonialism has rendered him not just suspect but distinctly 'politically incorrect' in the eyes of some late-twentieth-century historians. Pissarro had expressed doubts about his cynical exploitative attitude in the early 1880s and the swift changes in Gauguin's style later in the decade did not allay his fears. It has been shown how Cézanne was deeply suspicious of this restlessness of Gauguin's, his own artistic integrity being closely bound up in his identification with *pays*, with excavating the rich potential of the landscape in which he felt himself to be rooted. He resented the way Gauguin, having only a superficial grasp of his own artistic discoveries, was trailing a form of Cézannism around the world.

These caveats about Gauguin's enterprise would be more tenable if his paintings had been less inventive, and the image he had handed us of the South Seas had been blatantly seductive or mischievously paradisiacal. But the prevailing mood is of a melancholy Eden; the brilliant colours sing against predominantly sombre ones, a sense of questioning, loss and moral anxiety is unmistakable in the many paintings in which strongly formed, statuesque women brood, haunted by fear of ghost (fig.44) or white man, trapped in a hopelessly tainted paradise. These images belie the tourist postcards; rather than exploiting the legendary sexual liberation of the Polynesian such messages as they contain are more ambiguous. *Nevermore* (fig.45) is not just an echo of the refrain of Poe's famous poem, *The Raven*, which Gauguin would have associated with its French translator, the poet Stéphane Mallarmé, it is also, surely, a reflection on the irretrievability for the artist of Tahiti's past glories.

43
Odilon Redon

Woman of the East
*c.*1893
Pastel over charcoal on paper 39.4 × 34.4
(15½ × 13½)
Exh. Grafton Galleries 1910
Woodner Family Collections, New York

But maybe we read the images with the benefit of hindsight, with knowledge born of broader understanding of the reality of Gauguin's own circumstances and those of Tahiti under colonial rule. Perhaps Gauguin's example was a more dangerous one at the turn of the twentieth century, and it was possible to be duped into believing in the right of the artist to abandon all social responsibilities, overthrow all conventions and embrace a hedonistic oneness with nature. Certainly it would seem that some of his Bloomsbury admirers naively swallowed the bait, hook, line and sinker.

A common trait shared by the artists who, in Gauguin's wake, turned back to the primitive (whichever types of art they might choose to consider within the term), was their belief that the symbolic use of pure colour or

44
Paul Gauguin

Manau Tupapau:
The Spirit of the Dead
Keeps Watch 1892

Oil on canvas
73 × 92 (28¾ × 36¼)
Albright-Knox Art
Gallery, Buffalo,
New York, A. Conger
Goodyear Collection
1965

45
Paul Gauguin

Nevermore 1897

Oil on canvas
60.5 × 116
(23¾ × 45¾)
The Courtauld Gallery,
London

expressive manipulation of form they found in untutored art held a powerful truth capable of communicating with the emotions or the inner being or soul, an expressiveness lost in modern realist art. Whereas Cézanne, van Gogh and Signac aspired to reach a broad public, Gauguin and his followers were embarked upon a quest for an art that emulated religion in its emotional, affective power, even if it meant an art beyond the reach of the common people.

The different manifestations of romantic archaism were clearly distinct from the more optimistic position adopted by the Neo-Impressionists, who believed in the possibility of democratic progress. Their technical experiments grew out of a fascination with science, physics and mechanisation, exploited certain of the effects found in photography or

printing, and aimed to take control of the viewer's response, reproducing by systematic means the maximum luminosity of light and vibrations of colour. Although there was a similar underlying respect and need for order governing the various nineteenth-century attempts to systematise the chaos of unregulated empirical observations that seemed to them to constitute Impressionism, despite the efforts of critics like Denis and Fry, such nuanced distinctions were largely to be lost on the next generation of artists. They preferred to raid the past for examples of licence, not discipline.

3

After 1900

Modern French Art in Britain

It is important to remember that prior to the revelation of the Post-Impressionist exhibitions of 1910–13 there were various levels of awareness of French art among British artists. There had always been sporadic cross-Channel contacts, most of which seem to have passed unnoticed because the individuals concerned belonged to no particularly influential circle. Brittany was an international meeting point: it was there that the Mackies from Edinburgh met Sérusier and, through him, the rest of the Nabis in Paris, and there that Robert Bevan and Roderic O'Conor met Gauguin in 1894, nearly following in his footsteps to Tahiti. Both the latter proved important link figures since Bevan, with Walter Sickert, was prominent among the francophile London-based artists who formed the Fitzroy Street group in 1905 and later the Camden Town School, while it was O'Conor who steered Clive Bell towards an understanding of modern French art in Paris around 1904. Then there was the more sophisticated if idiosyncratic appreciation of certain aspects of recent French art by those artists and critics who spent long or formative periods in Paris: Sickert, Ginner, Augustus and Gwen John, J.D. Fergusson, Frank Rutter and Harold Gilman. Last, but not least, came the passionate conversions of the artists of the Bloomsbury group – Roger Fry, Vanessa Bell and Duncan Grant – predisposed to be receptive to the Post-Impressionist example. For them the excitement engendered by their discovery of what was going on in modern art in Paris answered a need

and was taken up more or less as a religion. It was not only extraordinary but indispensable to the kind of fervent clarity with which Fry and Bell wrote about art, that their contact with the works of Cézanne, van Gogh and Gauguin came in such a concentrated burst, swiftly followed by the discovery of the Fauves and meetings with Picasso and Matisse.

Although the influence of these English artists as individuals amounted to little (none of them had a following of students), the influence of the Bloomsbury set on taste in Britain was far-reaching, due to its network of contacts within the worlds of high society, literature, journalism, museums and politics. For the key players in Bloomsbury – Roger Fry, Clive and Vanessa Bell, Virginia and Leonard Woolf, Desmond MacCarthy, Maynard Keynes and Ottoline Morrell – the discovery of Post-Impressionism coincided with, and was taken to be part of, their ongoing challenge to established conventions, social beliefs and sexual repressions.

Between 1910 and 1912, the dates of the first and second Post-Impressionist exhibitions, the Bloomsbury artists as well as a wider circle of close and not so close associates including Wyndham Lewis, Bernard Adeney, and Frederick and Jessie Etchells, radically adjusted their artistic styles, substituting for the delicacy or low-key palettes of their various earlier manners elements of the bold colour, decorative patterning and simplification they found in Cézanne or Gauguin, the synthetists or the Fauves. So rapid was their conversion to the new ideas coming from France that by 1912 it was thought appropriate to show their work alongside the works of their French contemporaries. In his catalogue introduction to the English section of the exhibition, Clive Bell made grandiose claims for these new Post-Impressionist works, calling them 'manifestations of a spiritual revolution which proclaims art a religion, and forbids its degradation to the level of a trade'.

The questionable validity of this statement was put to the test only the following year when Roger Fry, with the full participation of Vanessa Bell, Duncan Grant and others, set up the Omega workshops, an attempt similar to that of the Nabis before them to give their new artistic ideals a more practical and commercial outlet. They had a measure of success too, gaining some significant commissions for mural decorations. However, disagreements in approach quickly provoked a splintering of the English movement between the more cultured, comfortably placed Bloomsbury artists and the more radical thrusting ambitions of Lewis and the Vorticists.

POST-IMPRESSIONIST THEORY: THE DENIS-FRY CONNECTION

It is ironic that Roger Fry, the originator of the term Post-Impressionism, has for so long taken sole credit for inventing the concept. As one might expect, the effort to rationalise and produce an intellectual synthesis of the artistic revolution that had taken place in French art in the 1880s was well advanced in France. Throughout the 1900s Maurice Denis, who had as a

young man been swept along by what he called 'that great current of ideas', was engaged upon a serious project of clarifying, and imparting to the younger generation, via a sequence of well-researched pedagogical articles, just what the key changes of aesthetic had been. Like Roger Fry, Denis brought to his writing considerable powers of reasoning, the authority of a broad knowledge of earlier art and his practical experience as a painter. And like Fry his influence as a writer, and indeed as a teacher at the Académie Ranson, extended and continued well beyond the more confined impact of his painting. It seems clear that the intellectual and artistic debt Fry owed Denis has not been sufficiently acknowledged.

Only after the deaths of Gauguin in 1903 and Cézanne in 1906 could such a historical synthesis be attempted. The committees of the Salon des Indépendants and of the new Salon d'Automne, founded in 1903, made it a policy for their annual exhibitions of contemporary art simultaneously to

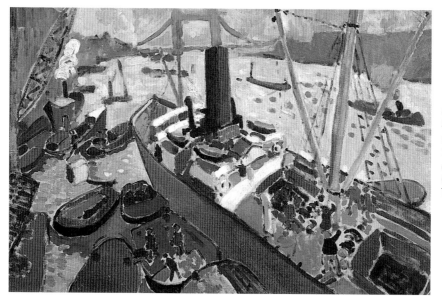

46
André Derain

The Pool of London
1906

Oil on canvas
65.7 × 99.1 (26 × 39)
Tate Gallery

pay homage to the masters of the previous generation. A series of seminal exhibitions ensued, which included the major posthumous retrospectives of Gauguin in 1906 and Cézanne in 1907. These afforded established artists like Denis the chance to reflect on just what the earlier artists had contributed, separately and in combination, to recent development in art. For younger artists like Maurice de Vlaminck and André Derain (fig.46), or for alert foreign artists visiting Paris like Spencer Gore, or the Americans Walt Kuhn and Maurice Prendergast, the exhibitions proved inspiring in a practical sense.

Like all historians Denis looked for patterns, determined to establish cohesive links between the great periods of earlier art and the important figures of his own day. In 1903, following Gauguin's death, he reflected upon the artist's influence on his own generation, which he summarised as the demonstration that 'art is above all a means of expression ... that every art

object must be decorative … that all grandeur, all beauty is worthless without simplification, clarity and homogeneity of *matière*'. In 1906, in a long article occasioned by the recent comparative showing of van Gogh and Seurat at the Salon des Indépendants, Denis argued that a major unifying factor in recent art had been the cult of the sun, worshipped, ever since Monet, as the (false) god of modern painting: 'alongside the learned, but limited system of the Neo-Impressionists, the cult of the Sun among painters had given rise to other less reasoned, more subjective methods, among which the lyricism of a Vincent van Gogh … an inspired, sometimes beautiful body of work, but an extremely dangerous example.'

Although he was cautious of over-inflating reputations, wary of the phenomenon of Cézanne's rising fortunes on the art market, Denis' long monographic article on Cézanne, which first appeared in 1907 in the wake of the Cézanne retrospective, presented the first cogent account of the artist's achievement, seeking to explain that mysterious method which had frustratingly remained beyond Gauguin's grasp. Roger Fry, clearly impressed by the article, decided to translate it for the *Burlington Magazine* where it appeared in two parts in January and February 1910. Whether the two men met or not is unrecorded, but in a hitherto unpublished letter, informing Denis of the dates of the forthcoming publication, Fry wrote: 'I want to express my keen admiration for the shrewdness of your critical judgment. Nobody else, I believe, has written about the present situation of modern art with such keen and fair understanding.' Perhaps it was Denis' article Fry was trying to correct when he had a fateful chance encounter with Vanessa and Clive Bell on the Cambridge to London train in January 1910, during the course of which he unveiled to their enthusiastic ears his plans to mount an exhibition of modern French painting, the exhibition that became *Manet and the Post-Impressionists*.

Certainly Denis' clear exposé reinforced Fry's own thinking about aesthetics in general and about the particular importance of Cézanne, whom Fry considered the cornerstone of Post-Impressionism. But what else was Fry able to learn from the article as he tried faithfully, in his translation, to retain the essence of its argument? A number of points would have struck a special chord. Denis emphasised the contrast between the classic, old-master quality of Cézanne's work and the works of his contemporaries, characterising the artist as 'reacting against modern painting and against Impressionism'. Denis argued that Cézanne's instinctively synthetic method had imposed a very necessary discipline on the disparate contrasts of colour used by the Impressionists, bringing him closer to the 'simplicity, austerity and grandeur' of Manet. He also made more general aesthetic points: 'Painting … is bound to be an art of concrete beauty, and our senses must discover in the work of art itself – abstraction made of the subject represented – an immediate satisfaction, a pure aesthetic pleasure.' We rediscover this idea in the formalist impulse behind Fry's concept of Post-Impressionism, in Fry's 'aesthetic emotion' and the work of art's 'plastic values', later developed by Bell into the concept of significant form.

'He [Cézanne] is at once', Denis concluded, 'the climax of the classic

tradition and the result of the great crisis of liberty and illumination which has rejuvenated modern art. He is the Poussin of Impressionism.' Fry in his turn constantly evoked the traditional aspects of Cézanne and the Post-Impressionists. In 1908, taking issue with an article concerning 'The Last Phase of Impressionism', he had argued that it was vital for the innovative artists working in the wake of the Impressionist revolution to separate art's aim from the mimetic aim of photography, diagnosing their anti-naturalist impulse as the thing that unified Cézanne and Gauguin: 'Two other artists, Mm. Cézanne and Paul Gauguin, are not really Impressionists at all. They are proto-Byzantines rather than Neo-Impressionists ... They fill the

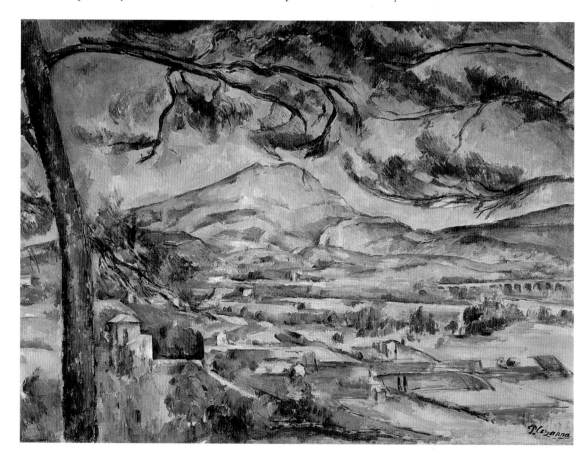

contour with wilfully simplified and unmodulated masses, and rely for their whole effect upon a well-considered co-ordination of the simplest elements.' Elsewhere, in 1910, he argued that to see the whole history of art in terms of progress was the great error. Every gain made in the name of skill of representation had entailed a loss, and the artists he dubbed the Post-Impressionists had realised this, hence their turning back to a much older decorative tradition: 'they are in revolt against the photographic vision of the nineteenth century, and even against the tempered realism of the last four hundred years.'

ENGLISH AND AMERICAN POST-IMPRESSIONISM

When *Manet and the Post-Impressionists* opened in November 1910 at the Grafton Gallery, English taste had scarcely moved beyond the Victorians' love of sentimental and illusionistic art; not surprisingly it aroused a storm of angry protest from critics and public alike. Alongside the dead masters Manet, Cézanne, Gauguin and van Gogh, were a somewhat motley collection of contemporary works by Matisse and his followers and by former Nabis like Vallotton and Denis. Given the absence of works by

47
Paul Cézanne

The Montagne Sainte-Victoire with Large Pine
*c.*1887

Oil on canvas
66.8 × 92.3
(26¼ × 36¼)
The Courtauld Gallery,
London

48
Vanessa Bell

Frederick and Jessie Etchells Painting 1912

Oil on wood
51.1 × 53 (20¼ × 21)
Tate Gallery

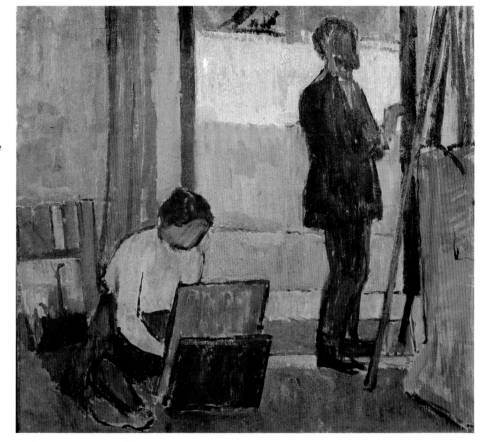

Vuillard and Bonnard, Denis' paintings, already familiar to the regulars of London's International Society (in 1910 he was honoured by this exhibiting group with the foreign artist's award), were surprisingly well represented. What the exhibition lacked in comprehensiveness, balance and contemporaneity (the selectors, Fry admitted, had been very much at the mercy of the Paris dealers who were more interested in serving the burgeoning demand for contemporary art from Russia and Germany) was compensated by Fry's lucid expositions in the catalogue and subsequent critical writing.

It is possible to see several different strands within the Post-
Impressionist mix of 1910 having an immediate impact on the self-conscious
'Post-Impressionist' movement in Britain. Cézanne of course was taken up
for the formalist reasons presented by Fry, in terms of his paintings' solid
structure and uncomplicated, unliterary, realist subjects. This slanted
reading was reinforced by the selection which, with the exception of two
bather subjects, concentrated on Cézanne's landscapes (fig.1), still-lifes and
portraits, and excluded his more difficult, imaginary subject pictures.
Vanessa Bell and Duncan Grant rapidly appropriated aspects of Cézanne's
handling and, liberated by his example, concentrated on the tactile subjects
of their immediate world, still-lifes, portraits of friends and familar
landscapes (fig.48).

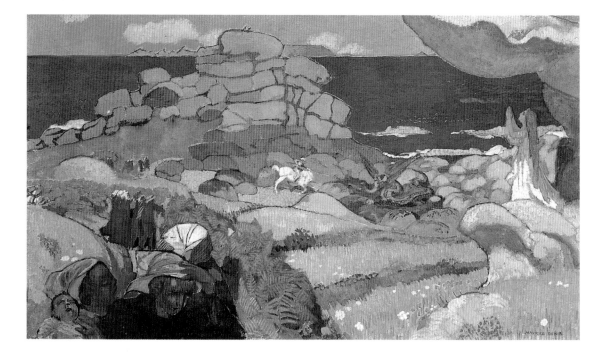

Complementing, but in part contradicting, this Cézannist trend came
the examples of Gauguin (figs.21 and 44), Redon (fig.43), and Denis
(fig.49), who in their different ways sought to expand the artist's repertoire
beyond the realm of immediate material reality and incorporate exotic
figuration or other-worldly imagery. Although in the short term Denis'
rhythmically ordered arcadian landscapes had an influence on the painting
of Fry and Vanessa Bell, notably in their schematic landscapes done in
Sussex over the following summers (figs.50 and 51), in a more general sense
the Bloomsbury artists' enthusiasm for garish colour, distorted drawing and
heightened expression was awakened by Gauguin and Matisse (fig.52). It was
they who gave rise to the enthusiasm for the exotic, decorative and primitive
in English Post-Impressionist art and design (fig.53), seen particularly in the
ornamentation of pots, screens and fabrics produced within the Omega

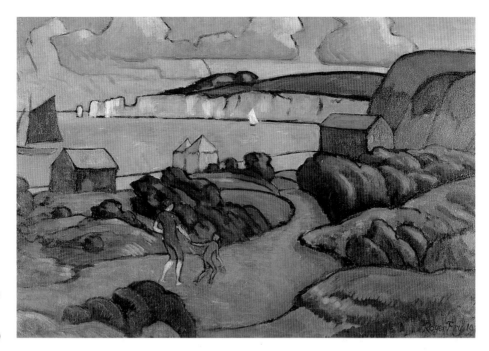

49 *left*
Maurice Denis

Saint George with Red Rocks 1910

Oil on canvas
75 × 130 (29½ × 51¼)
Exh. Grafton Galleries
1910
Musées d'Angers

50 *above right*
Roger Fry

Studland Bay 1911

Oil on canvas
58.5 × 90 (23 × 35½)
Rochdale Art Gallery

51
Vanessa Bell

*Studland Beach c.*1912

Oil on canvas
76.2 × 101.6
(30 × 40)
Tate Gallery

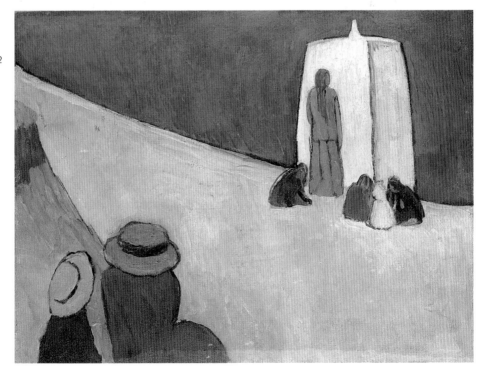

workshops. And in terms of content as well as form, Post-Impressionist simplicity and boldness provided a sure antidote to and safeguard against what Vanessa Bell recognised as a constantly lurking danger – the cloying, literary sentimentality that so appealed to popular British taste.

But there was also a third strand to English Post-Impressionism, not fully represented by either of Fry's shows, presumably because it did not readily fit his somewhat rigid definition of Post-Impressionism. This was the strand of domestic intimism of the kind practised by the artists of the Camden Town group, especially the francophiles of longer standing, Harold Gilman, Spencer Gore and Walter Sickert. The last, a great admirer of Degas, had exhibited with Bonnard and Vuillard at Bernheim-jeune's gallery in Paris and it was to their work, which he praised in his art criticism, that

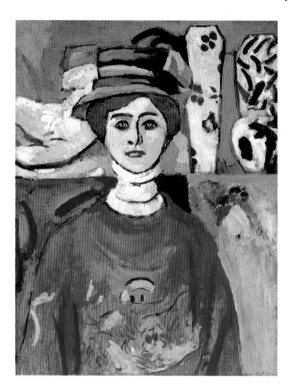 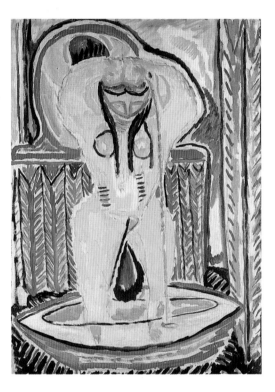

the Camden Town group were closest in spirit. Although Bonnard did not feature until the second Post-Impressionist show, and Vuillard not at all (an absence duly noted by Sickert), they were already reasonably familiar to these English artists, having been represented in various exhibitions over previous years. Overlaying this pre-existing sympathy, the impact of seeing Gauguin and van Gogh in 1910 led the Camden Town artists to embolden and intensify their colour use and textural patterning. This can be seen in the remarkably decorative landscape by Gore, *The Beanfield, Letchworth* (fig.54), where semi-abstract diagonal patterning is introduced to enliven the surface, or the extraordinarily garish colour yet tightly controlled structure of Harold Gilman's *Canal Bridge, Flekkefjord*, unthinkable without prior familiarity with van Gogh (fig.55).

52 *far left*
Henri Matisse

The Girl with Green Eyes
1908

Oil on canvas
66 × 50.8 (26 × 20)
San Francisco Museum
of Modern Art, Bequest
of Harriet Lane Levy

53 *left*
Duncan Grant

*The Tub c.*1913

Watercolour and wax on
paper laid on canvas
76.2 × 55.8 (30 × 22)
Tate Gallery

54 *above right*
Spencer Gore

*The Beanfield,
Letchworth* 1912

Oil on canvas 30.5 ×
40.6 (12 × 16)
Tate Gallery

55
Harold Gilman

*Canal Bridge,
Flekkefjord c.*1913

Oil on canvas
45.7 × 61 (18 × 24)
Tate Gallery

It is understandable that the term Post-Impressionism should have been so rapidly adopted in North America. For there too, over a similarly condensed period of time, modern foreign art made its clamorous bid for attention. Among those visiting the Armory Show in 1913 for instance, we find the pattern that greeted Fry's shows repeated: a public reaction of shock and outrage, but receptivity, and willingness to respond on the part of the adventurous, open-minded few. This huge exhibition had been deliberately tailored by its organisers (Walt Kuhn, Arthur B. Davies and others), to bring the American public up to date with the most modern tendencies in European art. The groundwork had been prepared by a sequence of exhibitions of individual French artists swiftly followed by

group shows of their American admirers, among them several well-informed, Paris-trained artists. More crucially there was a willingness on the part of collectors and critics (Arthur J. Eddy, for example, publishing his impassioned *Cubists and Post-Impressionism* in 1914) to take up the challenge their work raised.

One can discern various stages of assimilation by American artists of the various strands within Post-Impressionism. This is illustrated by the stylistic shifts over a relatively short span of Maurice Prendergast, one of the first, though not one of the most radical American painters to succumb to French influences. The Whistlerian subtlety of his early modern life subjects gives way in his Channel coast beach scenes of 1907 to the heightened colour and regularisation of touch associated with the Neo-

Impressionists and Fauves. These in turn, in works such as *The Picnic* of 1914–15 (fig.56), are succeeded by a grander decorative arrangement of arabesque forms and figures in timeless beach settings, strongly reminiscent of the classicising tradition represented by Puvis de Chavannes,

56
Maurice Prendergast

The Picnic 1914–15,

Oil on canvas
94 × 144.8 (37 × 57)
National Gallery of
Canada, Ottawa

57
Stuart Davis

Portrait of Man (Eugene O'Neill?) 1914

Oil on canvas
76.2 × 60.3
(30 × 23¾)
Curtis Galleries,
Minneapolis,
Minnesota

Henri Edmond Cross and Denis. The Armory Show provoked a more immediate process of assimilation in the young Stuart Davis, whose *Portrait of a Man* (fig.57) combines elements of the powerful design and expressive colour and form he had admired in Gauguin, van Gogh and Matisse.

Changes of Taste: The 1920s and Beyond

There was from the beginning of the use of the term Post-Impressionist a contradiction at its heart, one that Clive Bell put his finger on in his monograph on Sickert, written in 1944: 'to many of us post-impressionist meant anti-impressionist.' For those who had strong ties of loyalty to the original French movement, artists like Sickert or Lucien Pissarro, such antagonism was heretical. However one should be aware that the word Impressionist, as understood both in Britain and America in 1910, was more likely to conjure images of the imprecise, atmospheric painting practised by Whistler's followers than the work of Monet. Complicating the picture was the contemporary revival in France of interest in true Impressionism, of

58
Pierre Bonnard

The Window 1925

Oil on canvas
108.6 × 88.6
(42¾ × 35)
Tate Gallery

59
Pierre Bonnard

The Bath 1925

Oil on canvas
86 × 120.6 (34 × 47½)
Tate Gallery

which Bonnard's interiors are supreme examples. While Bloomsbury artists in the 1910s and 1920s were digesting their rich diet of Cézanne-inspired Post-Impressionism and Picasso-inspired Cubism, and while yet other developments were ousting Cubism from the centre stage in Paris, Bonnard and Vuillard were engaged upon what can only be described as a revision of Impressionism. Interviewed in 1937, Bonnard was well aware of how out of step with contemporary art he had been: 'when I and my friends adopted the Impressionists' colour programme in order to build on it we wanted to go beyond naturalistic colour impressions – art, after all, is not nature – we wanted a more rigorous composition. There was also so much more to extract from colour as a means of expression. But developments ran ahead, society was ready to accept Cubism and Surrealism before we had reached what we had viewed as our aim ... In a way we found ourselves hanging in mid air.' A full international appreciation of Bonnard's importance did not

come until the very end of his career in the 1940s, but certain British
collectors were quick off the mark. Lord Ivor Spencer Churchill, for
instance, acquired *The Window* and *The Bath* within only one or two years of
their completion (figs.58 and 59). The former is an assured example of
Bonnard's protracted meditation on the intimist interior, now flooded by
the light of the Mediterranean, the latter an early instance of his fascination
with an intimate subject long associated with Degas but which he imbued
with a new colouristic resonance.

Perhaps the most lasting effect of the Post-Impressionist era for the
British and American art world was that it gave a new direction to the
collecting patterns and policies of individuals and museums. Quite apart
from the many works by English Post-Impressionists that have found their

home in the Tate, most of the French pictures illustrated in this book,
whether belonging to the Tate, the National, or the Courtauld Institute
Galleries, can be directly linked, via their individual provenances, to the
revolution in taste brought about by Fry's exhibitions. It was through the
Contemporary Art Society, formed in 1910 as a complement to the National
Art-Collections Fund, that Fry acquired the first work by Gauguin for the
nation. This modest purchase heralded the instigation of a national modern
foreign collection at the Tate and a period of acquisitions of recent French
art that included the purchase of Gauguin's *Faa Iheihe* (fig.60) by Lord
Duveen in 1919, following its exhibition around America.

Maynard Keynes was among the Bloomsbury figures to begin his own

60
Paul Gauguin

Faa Iheihe 1898

Oil on canvas
54 × 169.5
(21¼ × 66¾)
Tate Gallery

collection at this time and a number of wealthy individual collectors – the Davies sisters in Wales and the textile millionaire, Samuel Courtauld – took their cue from Fry's exhibition. Indeed it was Fry and Bell's persuasive writings that redirected Courtauld's taste in the 1920s towards Cézanne and recent (if not contemporary) French painting. Courtauld not only built up his own private collection (now London University's Courtauld Collection), but also made a generous gift to the nation in 1924, to be administered by the Tate, of a purchasing fund of £50,000 earmarked for the purpose of building up the modern French collection. In the United States, Duncan Phillips was just one example of a collector who came under the spell of modern French art, becoming one of the staunchest supporters and collectors of Cézanne and Bonnard in the later 1920s, despite having earlier

railed against the Armory Show for being 'stupefying in its vulgarity'.

In 1996 a historic new agreement led to a redistribution of Post-Impressionist works between the Tate and the National Galleries. The Tate's display of modern European art now commences in 1900, while the most familiar Post-Impressionist masterpieces can be seen at Trafalgar Square, in the context of the traditions of the nineteenth century and earlier. What a turnaround since 1910, when a critic in *The Times* declared that Post-Impressionist art 'throws away all that the long-developed skill of past artists had acquired and perpetuated. It begins all over again – and stops where a child would stop'! It is a shift of emphasis that can be justified by reference to the traditionalist arguments of Denis and Fry. Let Walter

Sickert, however, have the last word. In his lecture, *Post-Impressionists*, delivered in the Grafton Gallery at the close of the first exhibition and printed in the *Fortnightly Review*, Sickert invited the sceptical viewer, one who may have shared the opinion of the *Times* critic, to look again at the Gauguins: 'To look first at the pre-Tahitian works, and their lessons exquisitely learnt from Degas and Pissarro ... to reflect that Degas inherits the tradition of Ingres and Poussin, and Pissarro those of Millet and Corot ... If in his Maori subjects, he simplified and transmuted his technique, taken largely from Cézanne, it was to become, in his young maturity, one of the finest flowers of modern European painting ... A strange grandeur has crept into Gauguin's figures, a grandeur that recalls Michelangelo ... Here is National Gallery quality at its highest level.'

While it was easy enough for Fry to sweep up the young generation in his Post-Impressionist crusade, in convincing well-informed, even establishment figures of the importance and staying power of this stylistic revolution, he brought off a much trickier and ultimately more significant victory.

SELECT BIBLIOGRAPHY

Anquetin, exh. cat., Galerie Brame et Lorenceau, Paris 1991

Bailly-Herzberg, Janine (ed.), *Correspondance de Camille Pissarro*, III, Paris 1988

Bell, Clive, *Art*, 1914

Bell, Quentin, *Bloomsbury*, 1968

Emile Bernard, exh. cat., Städtische Kunsthalle, Mannheim; Van Gogh Museum, Amsterdam 1990

Brown, Milton W., *American Painting from the Armory Show to the Depression*, Princeton 1955

Bullen, J. D. (ed.), *The Post-Impressionists in England*, London and New York 1988

Cézanne, exh. cat., Galeries Nationales du Grand Palais, Paris; Tate Gallery; Philadelphia Museum of Art 1995–6

Maurice Denis, exh. cat., Musée des Beaux-Arts, Lyon; Wallraf-Richartz Museum, Cologne; Walker Art Gallery, Liverpool; Van Gogh Museum, Amsterdam 1994–5

Denis, Maurice, *Le Ciel et l'Arcadie*, ed. J.-P. Bouillon, Paris 1993

Fry, Roger, *Cézanne: A Study of his Development*, London 1927

Fry, Roger, *Vision and Design*, London 1920

Gauguin, exh. cat., Art Institute of Chicago; National Gallery of Art, Washington; Réunion des Musées Nationaux, Paris 1988–9

Van Gogh, Vincent, *The Complete Letters of*, 3 vols., 1958

Gruetzner Robins, Anna, *Modern Art in Britain 1910–1914*, exh. cat., Barbican Art Centre 1997

House, John et al (ed.), *Impressionism for England: Samuel Courtauld as Patron and Collector*, London 1994

Hutton, John, *Neo-Impressionism and the Search for Solid Ground*, Louisiana 1994

Merlhès, Victor (ed.), *Correspondance de Paul Gauguin*, I, Paris 1984

Les Nabis, exh. cat., Réunion des Musées Nationaux, Paris; Kunstmuseum, Zurich 1993–4

Pickvance, Ronald, *Van Gogh in Arles*, exh. cat., Metropolitan Museum of Art, New York 1984

Pickvance, Ronald, *Van Gogh in Saint-Rémy and Auvers*, exh. cat., Metropolitan Museum of Art, New York 1986

Post-Impressionism: Cross Currents in European Art, exh. cat., Royal Academy of Arts, London 1978–9

Rewald, John, *Post-Impressionism: From Van Gogh to Gauguin*, New York 1956 (rev. ed. 1978)

Sérusier, Paul, *A.B.C. de la peinture*, La Rochelle 1995

Signac, Paul, *D'Eugène Delacroix au Néo-Impressionnisme* (1899), ed. Françoise Cachin, Paris 1983

Signac et Saint-Tropez 1892–1913, exh. cat., Musée de l'Annonciade, Saint-Tropez; Musée des Beaux-Arts, Reims 1992

Smith, Paul, *Cézanne*, London 1996

Spalding, Frances, *Vanessa Bell*, London 1983

Spalding, Frances, *Roger Fry: Art and Life*, London 1980

The Advent of Modernism: Post-Impressionism and North American Art 1900–1918, High Museum of Art, Atlanta; Center for the Fine Arts, Miami, Florida; The Brooklyn Museum, Brooklyn, New York; Glenbow Museum, Calgary, Alberta, Canada 1986

Thomson, Belinda, *Gauguin*, London 1987

Thomson, Belinda, *Vuillard*, London 1988

Thomson, Belinda (ed.), *Gauguin by Himself*, Boston and London 1993

Thomson, Richard, *Seurat*, Oxford 1985

Toulouse-Lautrec, exh. cat., Hayward Gallery, London; Réunion des Musées Nationaux, Paris 1991–2

Watkins, Nicholas, *Bonnard*, Oxford 1994

Watney, Simon, *English Post-Impressionism*, London 1980

INDEX